CARTOON CUTE ANIMALS

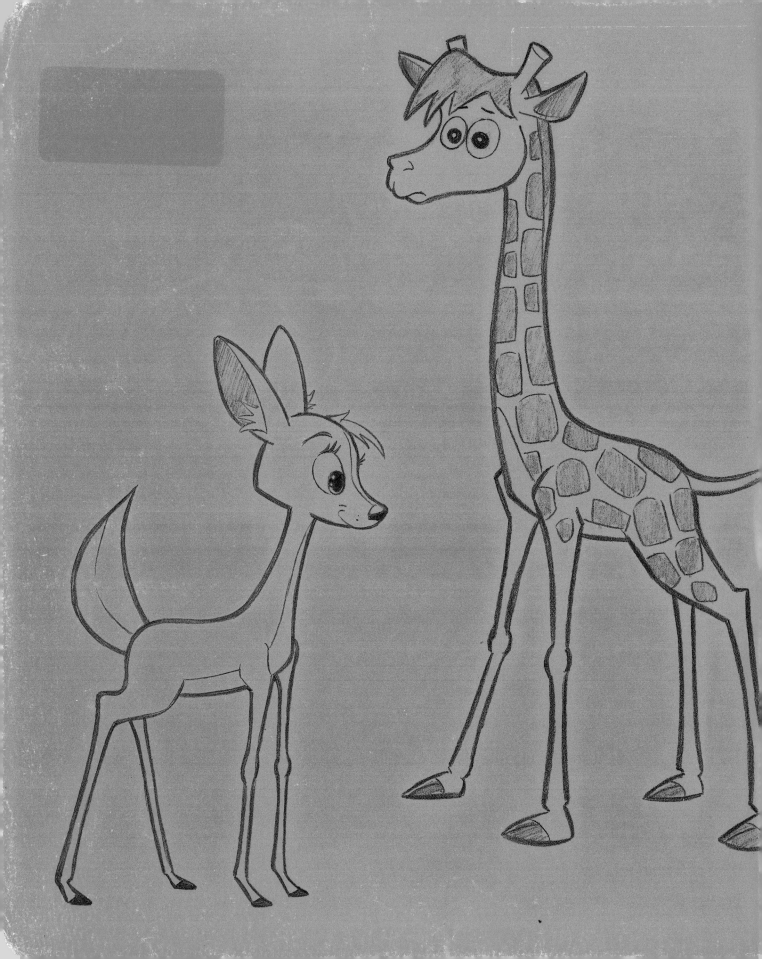

Christopher Hart

CARTOON CUTE ANIMALS

HOW TO DRAW THE MOST IRRESISTIBLE CREATURES ON THE PLANET

WATSON-GUPTILL PUBLICATIONS

NEW YORK

Copyright © 2010 Cartoon Craft, L.L.C.

All rights reserved.
Published in the United States by Watson-Guptill Publications,
an imprint of the Crown Publishing Group, a division of
Random House, Inc., New York.
www.crownpublishing.com

Library of Congress Cataloging-in-Publication Data
Hart, Christopher.
Cartoon cute animals : how to draw the most irresistible
creatures on the planet / Christopher Hart. -- 1st ed.
p. cm.
Includes index.
ISBN 978-0-8230-8556-9 (pbk.)
1. Animals in art. 2. Cartooning--Technique. 3. Drawing--
Technique. I. Title. II. Title: How to draw the most irresistible
creatures on the planet.
NC1764.8.A54H376 2010
741.5'362--dc22
2009035904

ISBN 978-0-8230-8556-9

Printed in China

Design by Vera Thamsir Fong

10 9 8 7 6 5 4 3 2 1

First Edition

For Bob and Alene Shorin

CONTENTS

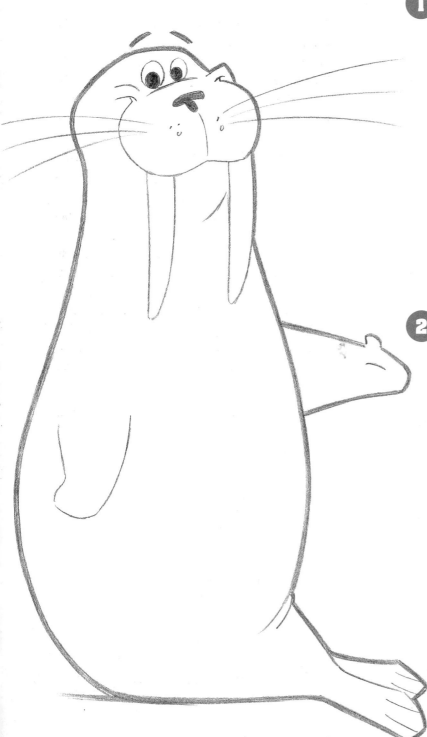

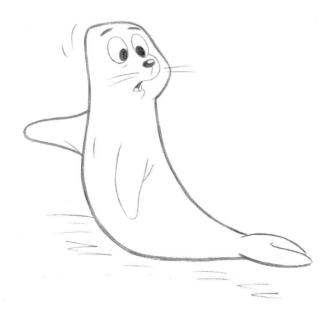

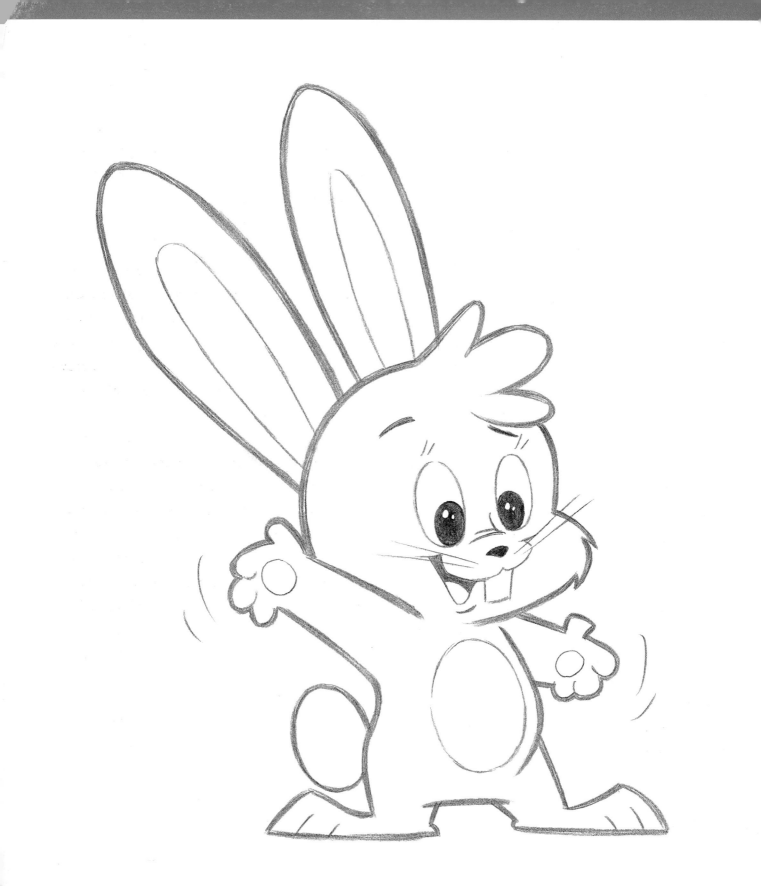

Introduction

Now, for the first time, you can learn the secrets professional cartoonists and animators use to turn regular animals into the adorable characters that audiences love. This book is designed to show you the exact techniques for putting that irresistible quality into your cartoons. Our favorite warm and fuzzy characters all have that "certain something." But what exactly is it? Although you may not be able to articulate it, this sought-after, ultra-cute quality is based on specific techniques that, when applied to character design, result in an irresistible cartoon animal. These are techniques that you can now learn, too!

With the right instruction, anyone can learn to draw those wacky and charming animals that tug at the heartstrings of readers. In addition to being a book for those who simply like to draw cartoons, this is also a practical guide for all aspiring cartoonists, animators, comic strip artists, and children's book illustrators. This subject is essential for them. And this book is the perfect go-to reference for those seeking inspiration for drawing all types of cartoon animals. The broadest possible spectrum of popular species is covered, including the character types that are currently the stars of television and the big screen. But it also features exotic animals, such as the ferret, badger, armadillo, meerkat, moose, wild boar, porcupine, lemur, and others not typically covered in a how-to-draw cartooning book.

We cartoonists use our pencils to guide readers' emotions along specific lines. As a result, readers worry when the cartoon animal is in trouble. They're sad when the animal appears lonely. They exult when the animal triumphs. We accomplish this through techniques that enhance character design, body language, and expression. All of these techniques are broken down in easy-to-follow, step-by-step instructions throughout this book. You won't have to "read yourself" into drawing better; instead, you'll be provided with plenty of visual examples.

This book features an extensive amount of illustrations and a generous offering of visual "side hints" designed to give you an edge up on your competition. The techniques presented here have been culled from years of experience and wrapped up into one simplified tome, which can save the newer artist countless hours of trial and error at the drawing table. It's everything you'd expect from a Christopher Hart drawing book—and more. Learning to draw has never been so much fun!

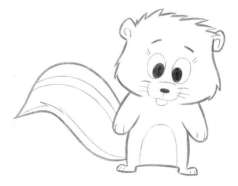

1

Getting Cute:
The Essentials

Appealing and charming characters are created, not born. By making use of certain elements, you can turn an ordinary cartoon animal into something special. There are seven basic ingredients that go into creating cute cartoon characters: proportion (both of the body and facial features), roundness (or squeezability), exaggeration (enough vs. too much), solidity (or three-dimensionality), rhythm (repeating shapes and lines create pleasing forms), perspective (foreshortening and overlapping), and cartoon anatomy (simplifying animal anatomy).

Audiences respond favorably to specific shapes and combinations of shapes. It's bred into us. For example, roundness is cute, chubby is cute, short is cuter than tall, and so on. By employing these elements and techniques, working on a subconscious level, artists create characters that evoke empathetic responses. That's the key. At the heart of it, our job is to manipulate the feelings of the reader. These techniques show us how to do it. How diabolical of us!

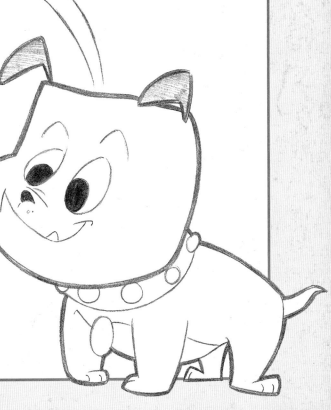

USING THE CENTER LINE

Before we get to the more specific character design stuff, there's one important technique to mention first: the use of the *center line*. The center line is a guideline artists use to indicate where the center of the form is falling in any given pose. If you're looking at a character head-on, the center line will be in the center of the form; if the character is in a 3/4 view, the center line will fall more toward the side of the form.

No matter whether the animal has a nose, a beak, or a trunk, the center line is still drawn down the length of the face, unifying it into one form. Notice how the center line, by following the contours of the head, accentuates the roundness of the face. But it's only a sketch line. Its sole purpose is to help you visualize a more solid foundation in the initial sketch. You erase it in the final drawing.

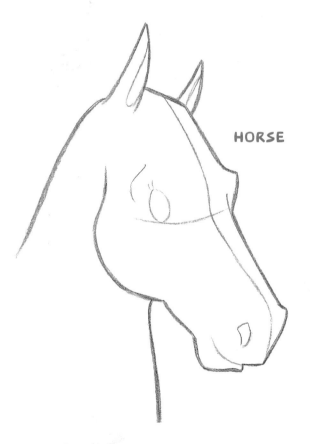

HORSE

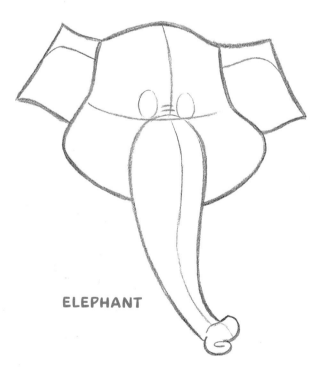

ELEPHANT

CHIPMUNK

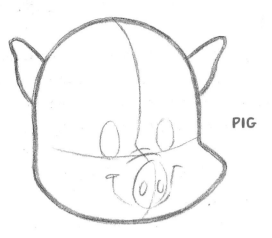

PIG

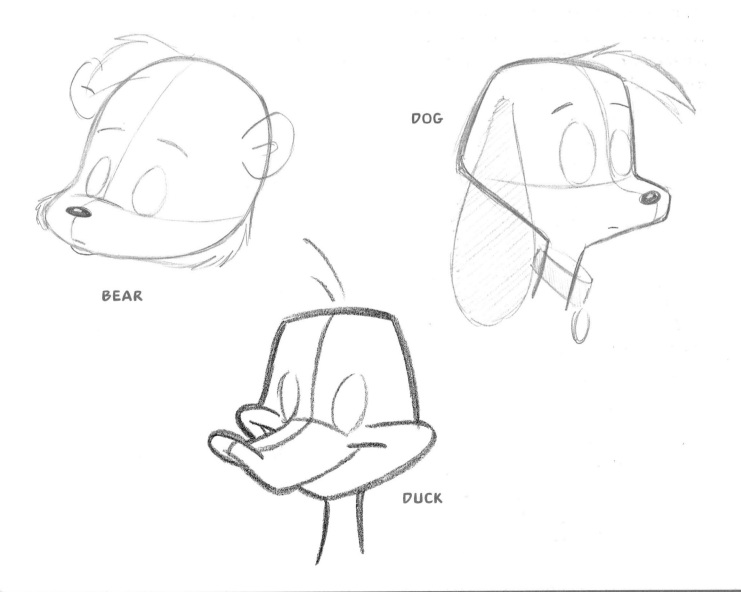

DOG

BEAR

DUCK

FACIAL PROPORTIONS

There are two keys to drawing the cute-shaped head: First, place all of the features as low on the face as possible. Get them down really far. Start by placing the nose, and then work around that as the focus for your constellation of features.

Second, draw the top of the head (the skull) larger and wider than the jaw/cheek area below it. In this way, you mimic the youthful proportions of toddlers. Compare goofy vs. cute here to see the difference.

GOOFY

The goofy character's features appear halfway down the face, which isn't quite low enough to produce that adorable look we're after.

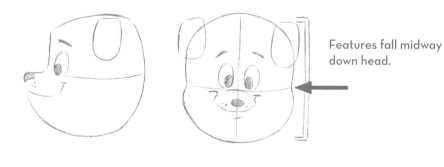

Features fall midway down head.

CUTE

Ah, now that's a cutie if I've ever seen one. By lowering the nose and surrounding features, we change the result appreciably. The nose and mouth are about as low on the face as you can position them, with the eyes following in step. Now the look suddenly transforms from a goofy expression into a charming one. Another important adjustment is the wider placement of the eyes.

Top of head is large and wide, like toddler proportions.

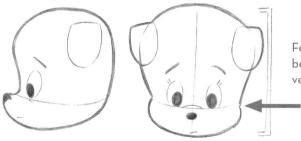

Features fall well below halfway point— very low on face.

Bottom of face (jaw/cheek area) is pudgy and smaller than top of head.

More Proportion Tips

These are a few character-specific tips that, when incorporated into your drawings, will help your cartoons look younger, which is always cute. Notice how big an impression these slight changes make. A small shift here, a little adjustment there, begins to change the nature of a character. Add enough small changes and you've invented something completely new, without altering the overall design.

SHORTER SNOUTS ARE MORE APPEALING THAN LONGER ONES

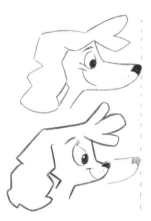

Long poodle snout = goofy.

Short poodle snout = cute.

BIGGER EYES & PUPILS ARE MORE ADORABLE

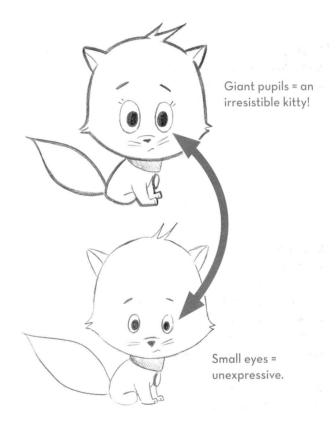

Giant pupils = an irresistible kitty!

Small eyes = unexpressive.

SMALL (OR EVEN NONEXISTENT!) JAW IS BETTER

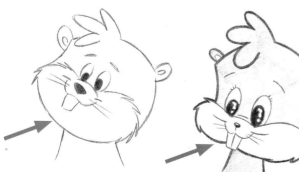

Fat jaw = goofy.

Small jaw = cute and more appealing.

APPEALING EYES

The latest trend in the animation industry is to draw endearing characters with giant-size pupils (but no irises), leaving less space for the whites of the eyes. The eye itself is not necessarily huge, but the pupil inside of it is.

CLOSED

Draw the edge of the eyelid with a darker line than the rest of the eye. There's no need to draw a bottom eyelid; the top one suffices.

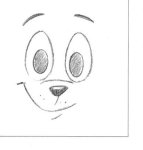

ANTICIPATING

The pupils float in the middle of the eyeballs.

JOYFUL

Big pupils, slightly cross-eyed, but still looking straight ahead.

UNSURE

The eyes tilt in the direction of the look, as if the pupils are pulling the eyes.

LAUGHING

The eyes become slits angled downward toward the nose.

DISCOMBOBULATED

One eyeball is small and ringed, while the other is large.

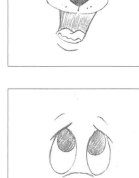

WORRIED

The eyebrows crush down on the eyes.

EXTREMELY HAPPY

Super-large eyeballs leave almost no whites of the eyes. And the eyes suddenly grow big lashes!

H!NT

The eye itself changes shape when the face makes different expressions. Beginners usually rely exclusively on the eyebrows to create eye expressions. Mistake! That's only using half the tools available to you, and it limits the expressiveness.

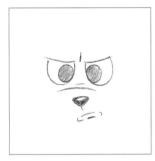

ANGRY

The eyebrows crush down, abruptly cutting off half the eyes.

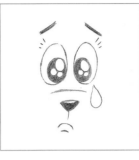

DEWY

Multiple shines appear in large, dark pupils.

Eyebrows: Options for the Smile

There are several ways to draw the eyebrows on a smiling character. Each offers a slightly different take on the expression. It's good practice to mix them up, which adds variety.

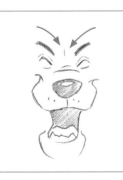

Both eyebrows angle down.

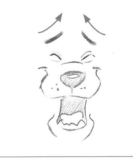

Both eyebrows angle up, and the ends curve upward.

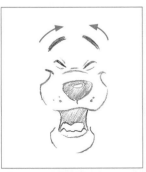

Both eyebrows angle up, but the ends curve downward.

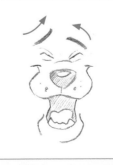

One eyebrow angles up and curves upward, while the other angles up but curves downward.

THE MUZZLE

Think of the muzzle as a cute, little shape that's attached to the basic head shape. It's easier to draw this way. The head shape is usually drawn first, without the muzzle, which is drawn second. The smaller the muzzle, the cuter the character (in this case, a dog). Keep the chin small or nonexistent on cute characters.

The muzzle falls between the two eyes at the intersection of the center line and the eye line (a guideline artists use to rest the eyes on).

The muzzle is a small oval shape.

The "Rubberiness" of the Muzzle

Think of the muzzle as putty. You can stretch and compress it into any shape. This results in many charming and funny expressions. Note that the muzzle conforms to the shape of the mouth, not the other way around. If the mouth stretches open tall, the muzzle will be tall. If the mouth opens wide, the muzzle will be wide.

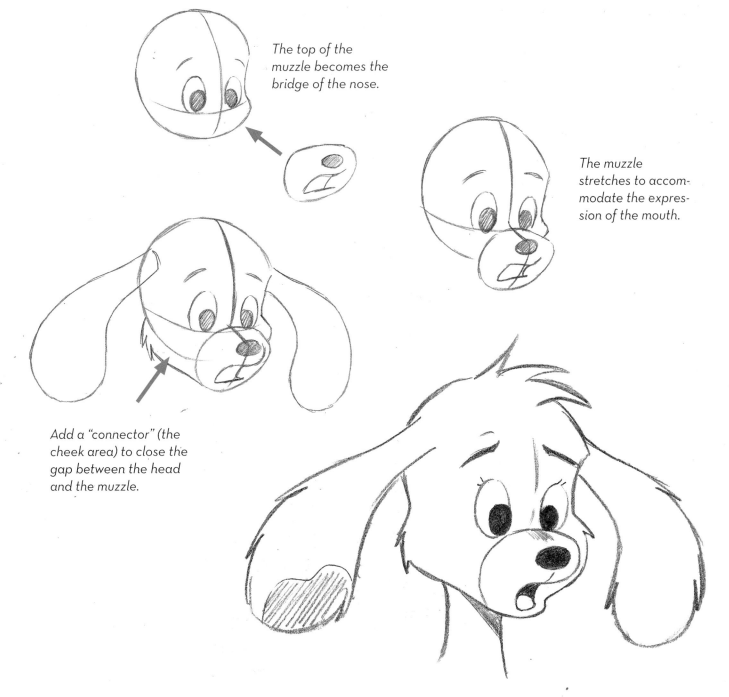

The top of the muzzle becomes the bridge of the nose.

The muzzle stretches to accommodate the expression of the mouth.

Add a "connector" (the cheek area) to close the gap between the head and the muzzle.

AN EXPRESSIVE SMILE

You can't just draw a smile, as if that's all there is to it. If you do, your smiling characters will never attain that sparkling grin you see in your favorite animated shows. Let's fix that state of affairs right now! A smile is more than a simple line that curves upward. And although there are many types of smiles, we're more concerned with conveying a sense of "dearness." Remember that the wider the smile, the goofier the look. But this isn't necessarily a drawback. A character who is drawn with the requisite cute characteristics—but who also exhibits a wide, goofy smile—can be quite appealing. The smaller smile is usually the cuter one, while the goofier smile is the funnier one.

GOOFY SMILE
The wider smile is pleasing but not as sweet.

CUTE SMILE
The smaller smile is less wacky but more endearing.

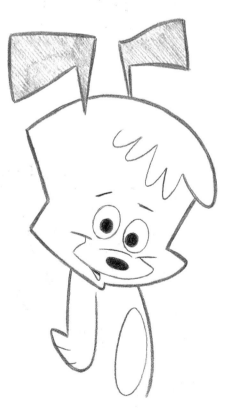

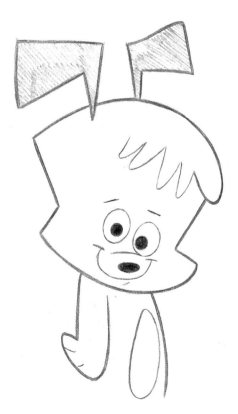

The Open-Mouth Smile

This might look like just a little thing, but it's actually important: The simple curved line used by the majority of beginners to depict an open-mouth smile is weak. Yet this is how most people draw it. By tweaking it slightly, you add that extra sparkle. Let's take a closer look.

One curved line never makes a truly charismatic open-mouth smile.

This smile is actually two lines drawn angling away from each other. This creates a genuinely appealing smile, brimming with happiness. Try it!

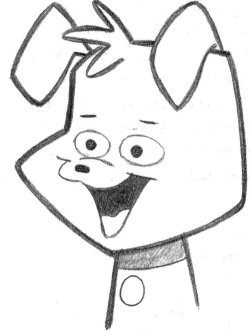

The Secrets to an Even Cuter Smile

To "push" the smile even farther, you have to scrunch it up into the corner crease line at a slightly different angle. Then it reads as real joy, and the smile becomes contagious.

SO-SO SMILE
It's one simple curve and not terribly evocative.

EFFECTIVE SMILE
This smile just beams. An expressive smile, which radiates happiness, travels high up on the face and stops at the bridge of the nose, not below it. Note how the smile line actually consists of two angles.

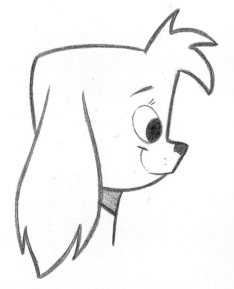

TURNING ORDINARY EXPRESSIONS INTO ULTRA-CUTE ONES

Eyes, noses, and mouths . . . check. Okay, we're ready to move on to expressions! It only takes a little tweaking to shift an ordinary expression into the charming range. Most of these ordinary expressions are drawn well, but they're not expressive enough to grab the audience. They're generic. They show general feelings, whereas the cute expressions are more specific. The more specific you can make an expression, the more effective it will be at conveying a particular emotion.

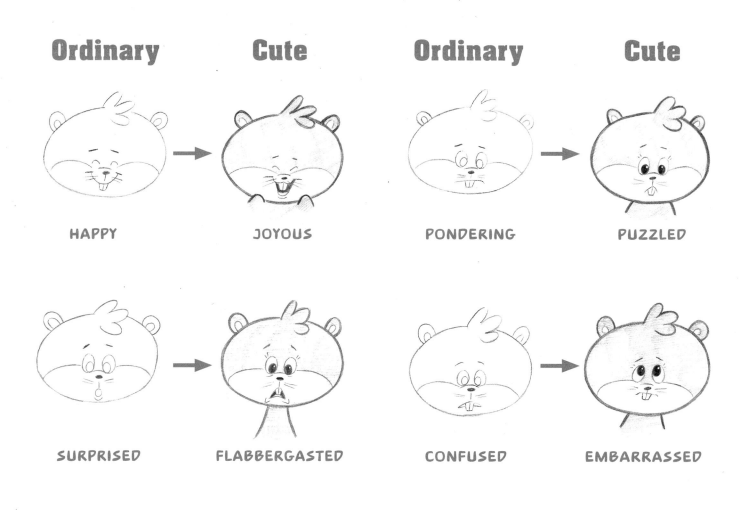

Ordinary → **Cute** **Ordinary** → **Cute**

HAPPY JOYOUS PONDERING PUZZLED

SURPRISED FLABBERGASTED CONFUSED EMBARRASSED

Ordinary # Cute

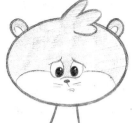

UNHAPPY HURT

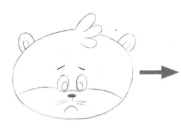

UPSET TEARFUL

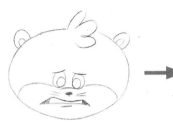

ANGER ANNOYED

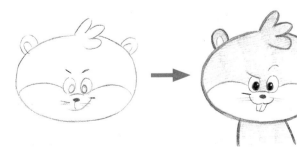

PLAYFUL MISCHIEVOUS

THE NECK AND SHOULDERS

There are a variety of ways to draw the neck and shoulders, and it comes down to personal preference. Sometimes artists eliminate the neck entirely and draw the head directly on the shoulders. This makes the character look plumper. A thin neck, on the other hand, makes a character look perky. A thicker neck is for more muscular, athletic animals or mature adults.

SKINNY & LONG

THICK & MUSCULAR

NO NECK (HEAD PLACED DIRECTLY ON SHOULDERS)

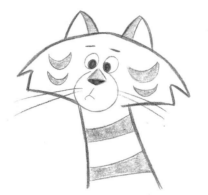

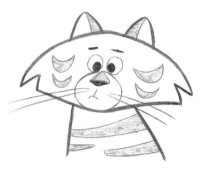

ULTRA-SKINNY NECK

NO NECK

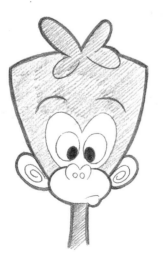

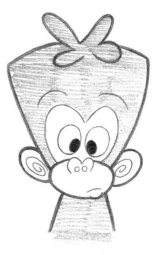

ANTHROPOMORPHISM

To anthropomorphize something is to give it human characteristics, form, or personality. The most important aspect of anthropomorphism for cartoon animals is not hands or feet but posture. Cartoon animals can stand on all fours, like a real critter. Or they can walk upright, on two feet, mimicking human posture. There's also an in-between stage. Let's look at the three basic approaches for drawing ultra-cute cartoon characters.

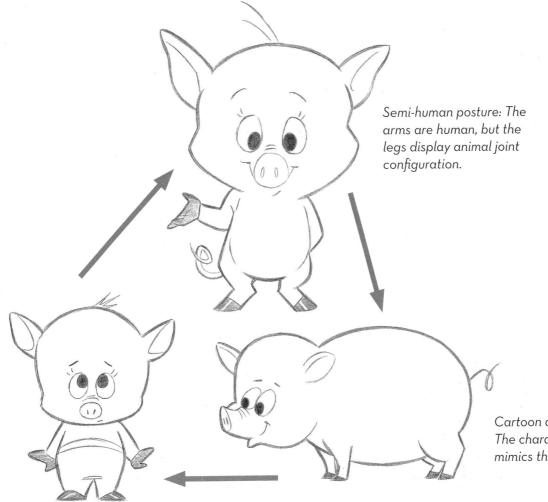

Semi-human posture: The arms are human, but the legs display animal joint configuration.

Cartoon animal realism: The character's posture mimics that of a real pig.

Human posture: Here there's no difference in posture between a human and the pig.

BODIES IN PERSPECTIVE

To draw the body in perspective, divide it into two circular sections. Actually, it's more accurate to think of these circles as spheres, because a sphere connotes a three-dimensional, solid object. The near circle (when the character is facing front) represents the rib cage, and the far circle represents the hips or bottom. No matter which direction the animal faces, the circle closest to the reader should overlap the circle farthest from the reader, unless the character stands in profile or near-profile. This gives the illusion of perspective and makes the critter look real and three-dimensional. When the figure is on all fours, the dip in the back between the two circles also makes the character look solid and appealing.

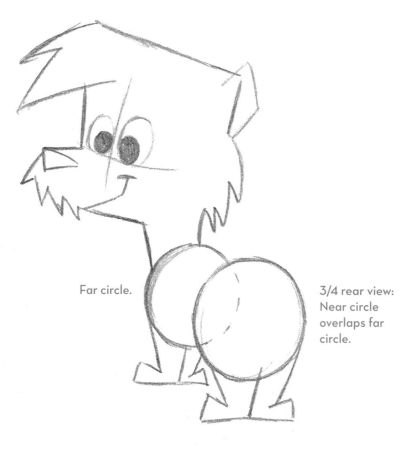

Far circle.

3/4 rear view: Near circle overlaps far circle.

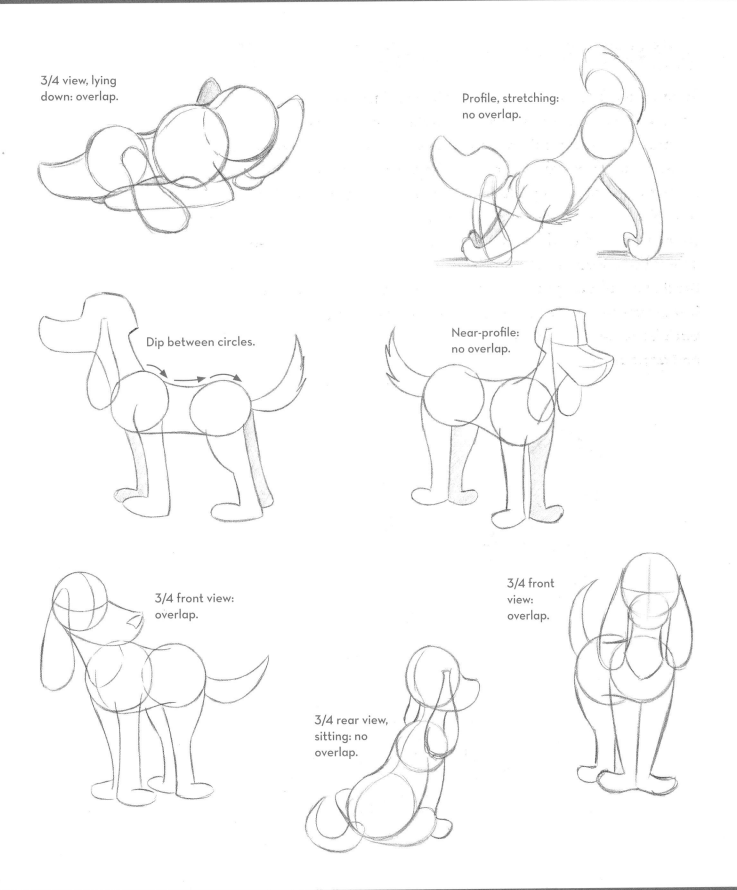

3/4 view, lying
down: overlap.

Profile, stretching:
no overlap.

Dip between circles.

Near-profile:
no overlap.

3/4 front view:
overlap.

3/4 front
view:
overlap.

3/4 rear view,
sitting: no
overlap.

BODY SHAPE

The body of a cute character needs a slight curve in the back and a protruding tummy. Adding a curve to the lower back forces the tummy to stick out in an adorable manner. Most cute characters are also bottom-heavy.

Curve in back.

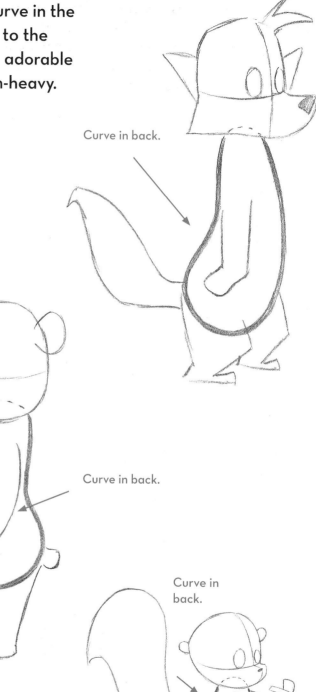

Curve in back.

Curve in back.

Curve in back.

H!NT

There are no straight backs on cute animal characters, unless the design is purposely super-stylized to look angular.

Torso Consistency

Whether the character is standing on four legs like a real animal or on two legs like a human, the shape of the torso remains the same. And this holds true for most cartoon mammals, including dogs, cats, bears, and small woodland creatures. In this way, you retain the cuteness of the character no matter which way you decide to draw it.

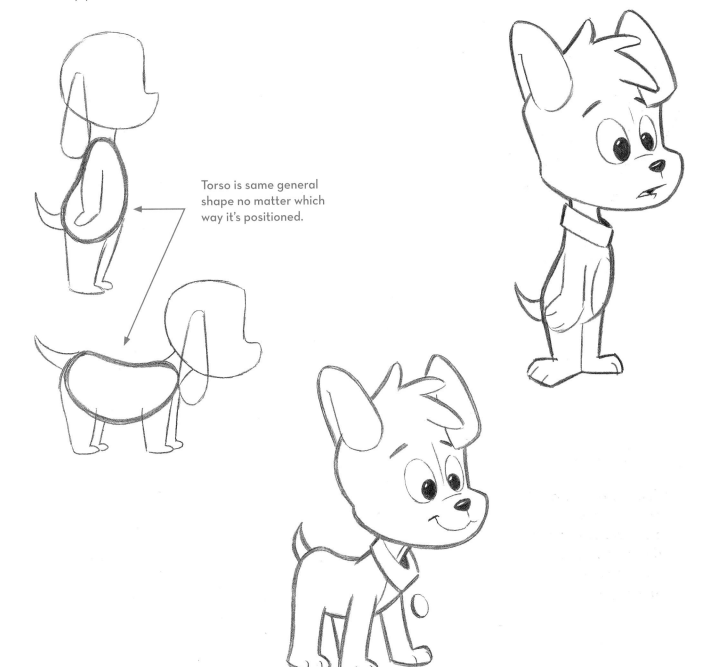

Torso is same general shape no matter which way it's positioned.

HEAD-TO-BODY RATIO

The general rule is this: The cuter the character, the bigger the head will be compared to the body. You can, of course, always find exceptions; but by and large, this works quite consistently across the board. Sometimes, a cute head is drawn so large that it's actually bigger than the entire body. This is effective because large heads, relative to body size, are the proportions of youthful characters—and youngsters come off as cuter than adults, naturally. When you begin your drawing, check the proportions to be sure that the head is sufficiently large to create a youthful appearance.

HEAD LARGER THAN BODY

HEAD 1/2 LENGTH OF BODY

HEAD 1/2 LENGTH OF BODY

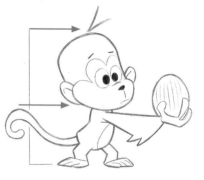

Other Animals with Oversized Heads

You can draw virtually any animal with an oversized head, including beavers, dogs, and ducks, for example. Reptiles are trickier, as it takes a little more of a deft touch to turn cold-blooded animals into cuties, but it can be done. (We cover that on pages 156–159.)

TORSO FLEXIBILITY

The torso of cute cartoon characters is never stiff. It's malleable. It bends and leans, stretches and compresses to accommodate and exaggerate every conceivable pose. Allow the torso to direct the pose. Don't lead with the limbs—have the limbs and the torso move in unison. The appeal of this pose comes not from the chipmunk's raised arms but from the stretch of its torso.

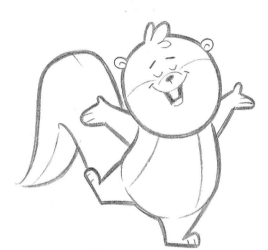

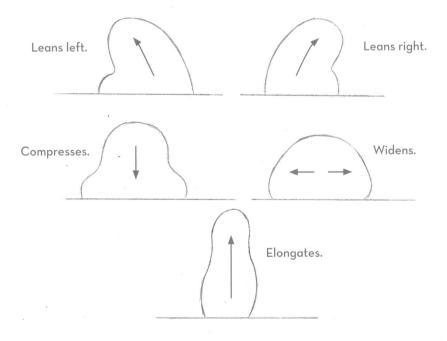

Leans left.

Leans right.

Compresses.

Widens.

Elongates.

BODY LANGUAGE: ORDINARY ACTIONS VS. CUTE ACTIONS

Just as a facial expression conveys an emotion, so too can a pose and a posture express attitude. Ordinary poses are made more endearing by drawing them both stiff and round at the same time. So the torsos become more flexible, but the limbs become stiffer and outstretched. In these before-and-after examples, adjustments have been made to each ordinary pose to bring out a lovable quality. In all the cute poses, the bear's form looks more exaggerated and energetic, a pleasant by-product of a fully developed character design.

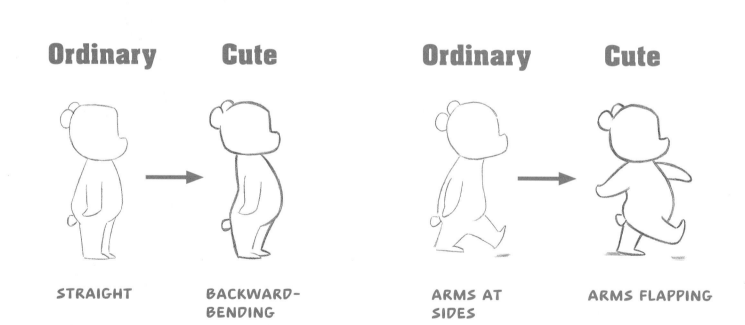

Ordinary **Cute** **Ordinary** **Cute**

STRAIGHT BACKWARD- ARMS AT ARMS FLAPPING
 BENDING SIDES

 H!NT Although most cuter poses show the limbs stiff and outstretched, there are exceptions, such as when the limbs are tucked in, causing the middle of the back to dip and resulting in a sweet gesture, as in the last image on this page.

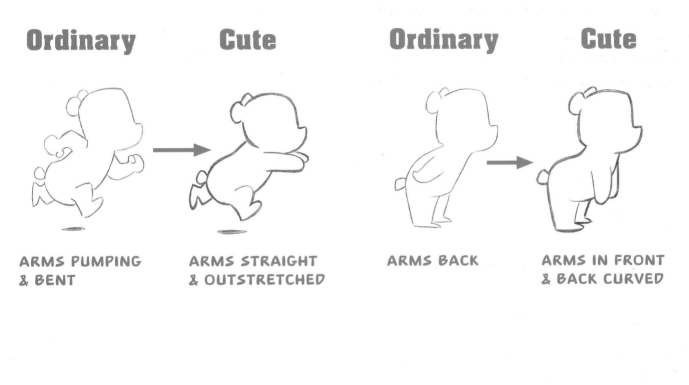

Ordinary **Cute** **Ordinary** **Cute**

ARMS PUMPING & BENT ARMS STRAIGHT & OUTSTRETCHED ARMS BACK ARMS IN FRONT & BACK CURVED

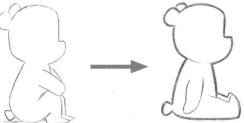

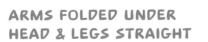

LEGS BENT LEGS EXTENDED ARMS FOLDED UNDER HEAD & LEGS STRAIGHT HEAD IN HANDS & LEGS CURLED UP

Dogs & Cats

Now we'll move on from the basic design principles behind creating endearing characters to drawing the actual animals themselves. This is the real meat of the book. If you've been studying the first section, you're now a lean, mean, well-oiled cartooning machine ready to draw the cutest animals on the planet. We'll start with two of the most popular types: dogs and cats. You can copy the characters here exactly as you see them or simply use them as inspiration—springboards for your own creations. So get out that pencil, pull out some paper, and let's get started.

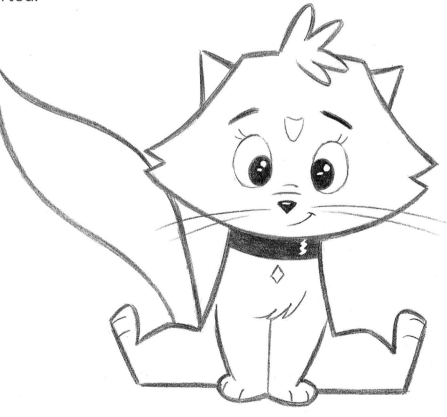

HAPPY MUTTS

Large, glistening eyes; a rubbery nose and mouth; and long, floppy ears—typical cute-animal cartoon qualities—can be transplanted onto any breed of dog or onto mutts, as well.

Everything centers around the muzzle. The eyes are placed on top of it, for example, spaced wide apart. Then there's that big, happy-dog grin that we love to see on adorable canines. The tongue falls out of the mouth at an angle, and, on this guy, two buck teeth show. The snout is also short—as it always is on cute pups. The top of the head is narrow, but the cheeks are quite wide. He's a mutt by way of the random, non-breed-specific markings on his ear and his eye patch. A big shock of hair gives him a floppy, youthful appearance, like a good-natured rogue, which is a popular character type.

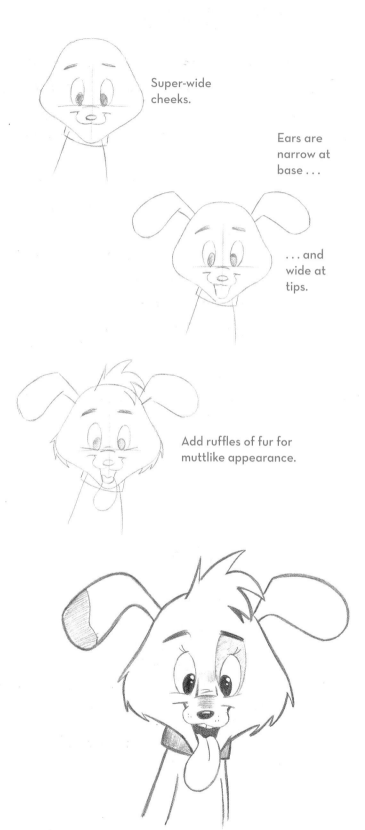

Super-wide cheeks.

Ears are narrow at base . . .

. . . and wide at tips.

Add ruffles of fur for muttlike appearance.

PUREBREDS

Unlike with mutts, when you draw an official breed, you need to draw the breed characteristics. That's what happens here with this cocker spaniel, who's a little cutie with giant eyes and a gumdrop of a nose. With eyes this big, I believe it requires adding at least two, and sometimes even three, eye shines to the pupils. If the character is a "boy," such as this one, a few short eyelashes add dearness. But the longer the lashes, the more you feminize the character.

Unlike the pup on the previous page, this one's head shape is more like that of a toddler: big forehead and smaller cheek area. The ruffles on top of the ears are typical of a purebred spaniel.

Forehead is high.

Cheeks are wide and low on face.

Eyes are large ovals.

There are a variety of subtle angle changes to the smile.

Pendulum-style ears.

Cheeks push up against eyes.

H!NT

Although I like using color as much as any cartoonist, I also love the shading you can get from the simple, and wonderful, pencil. You can't beat it for the feeling of energy and immediacy it communicates. All pencil shading in this book was done by hand. Not one bit of it was done with a computer.

FRONT VIEW

Here's a dog with medium-size, floppy-style ears. (See page 45 for more on ears.) They go up and then flop over toward the front of the face, which shows alertness. Like most cartoon dogs, this guy has a wide face. This is accentuated by the ruffles of fur at the edges of the cheeks.

So what are a few other things that make this a successful drawing? The features are placed toward the bottom of the head (note the low placement of the eye line). Also, the petite nose and tiny mouth contrast humorously against those giant eyes.

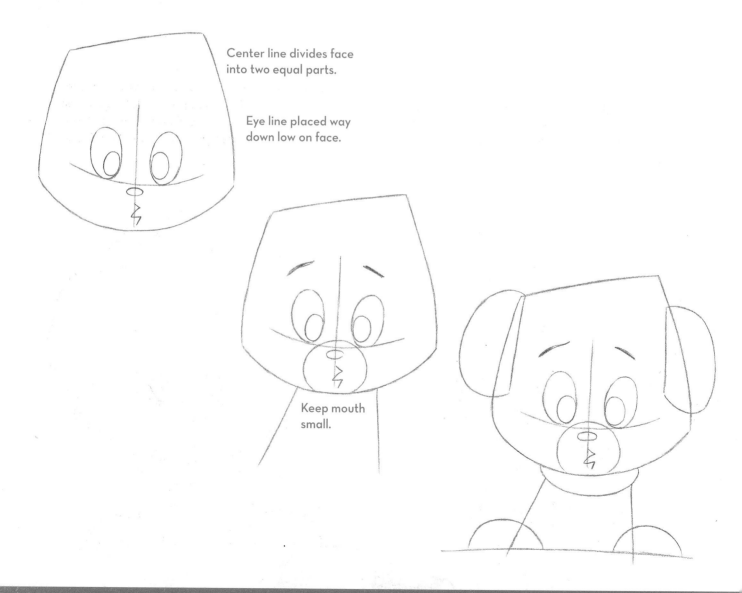

Center line divides face into two equal parts.

Eye line placed way down low on face.

Keep mouth small.

The Effect of No Neck

Eliminating the neck makes the dog look pudgier and a little younger. The collar is drawn directly under the head, with no space between—a tight fit is a cute look.

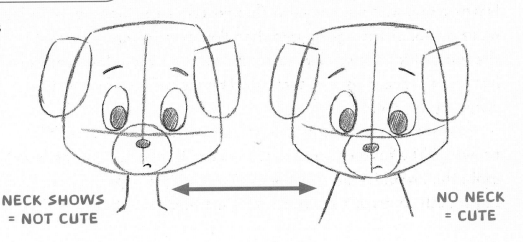

NECK SHOWS = NOT CUTE

NO NECK = CUTE

INITIAL SKETCH

Many aspiring artists believe that the pros' drawings never need erasing or tightening and that they draw a picture perfectly the first time. Nothing could be farther from the truth. Pros draw sketchily at first and clean their drawings up later.

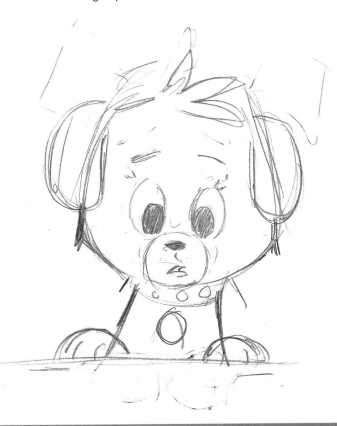

FINAL DRAWING

To create a clean final from a rough, trace over the initial sketch carefully, making only small adjustments as you go along. If something doesn't look right, go back and fix it on the rough version, and then trace over it again.

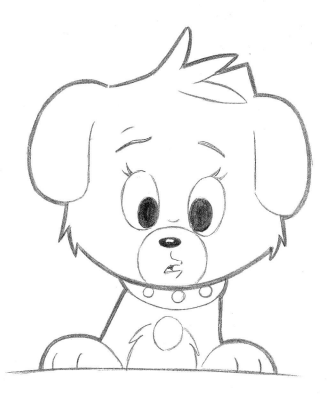

HYBRID 3/4 VIEW

This guy exhibits the elements of a 3/4 view. He has the classic cheek protrusion on the right side of the face, which is a sure sign that we're seeing a 3/4 view. In addition, the mouth is turned to one side, also to the right. Since the cheek protrusion is on the right, the mouth also has to turn to the right. Keep it consistent. Then the hair and ears are brushing toward the right, yet the eyes and nose are in a front view. This makes the character "cheat" more to the reader and gives the reader a fuller look at the face.

The main reason the neck is omitted here is because the head is so huge that any type of neck would look too skinny—like a bowling ball on a toothpick. You avoid this by attaching the head directly to the shoulders.

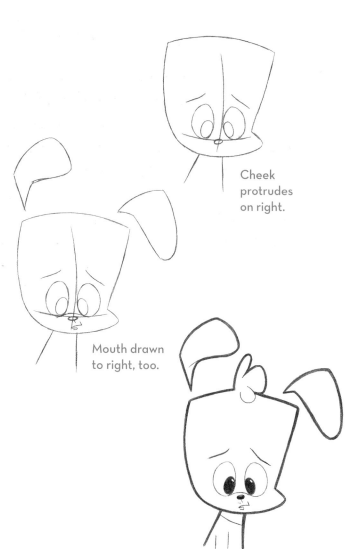

Cheek protrudes on right.

Mouth drawn to right, too.

The Correct Way to Draw the Pupils

The pupils should be complete ovals or circles drawn inside the eyes. Don't allow them to be cut off by the outer outline of the eye.

RIGHT
The pupil is a complete oval inside the eye.

WRONG
The pupil is cut off by the eye.

THE DOG BODY HEAD-ON

This night-eyed guy is a terrier. Terriers have an alert look about them. They're highly intelligent dogs, full energy, but sometimes hard to control. I had a terrier once, a cross between a schnauzer and a poodle: a "shnoodle"! Terriers are famous for the mustache across the front of the face. But remember, we want our dogs to look cute and not like old men with droopy mustaches. The way to do this is to minimize the size of the mustache so that it appears the mouth is only slightly ruffled. This also requires that the mouth itself remains small. Note that we never draw a true front view or we'd only see the two front legs. Instead, angle the character just a bit so that just a bit of the hind section is visible.

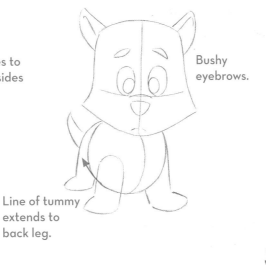

Square top of head.

Fur comes to point at sides of face.

Round chest.

Bushy eyebrows.

Line of tummy extends to back leg.

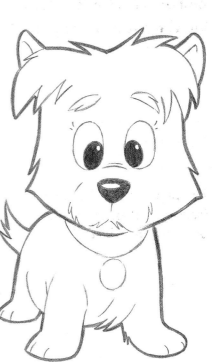

H!NT

Terriers are "chesty" dogs. But de-emphasize this on cute characters by making the body look round and compact overall.

POOCH IN PROFILE

Here's a real cutie, with a recessed chin and pendulum-style ears. Notice how large the head is compared to the neck. A short little snout completes the profile. Note that the eye isn't drawn right up against the line of the forehead but is set back a bit. I also like to show just a hint of eyelashes peeking out from the far side of the head; this makes the reader think that there's an eye on the other side and therefore emphasizes the roundness of the head.

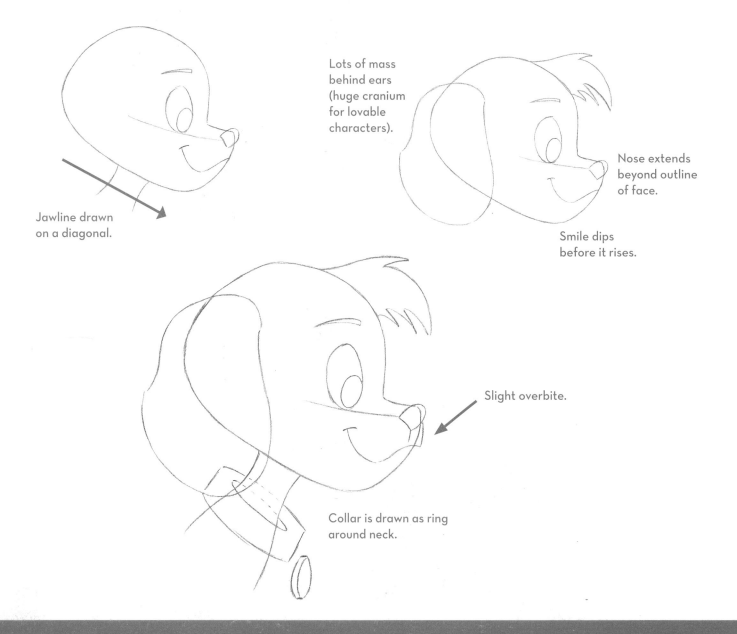

Jawline drawn on a diagonal.

Lots of mass behind ears (huge cranium for lovable characters).

Nose extends beyond outline of face.

Smile dips before it rises.

Slight overbite.

Collar is drawn as ring around neck.

The Collar: Wrong vs. Right

The collar isn't straight but oval, even in the side angle. To indicate this, draw it curved. This means we can see the interior of the far side of the collar.

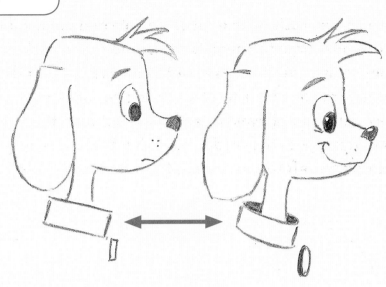

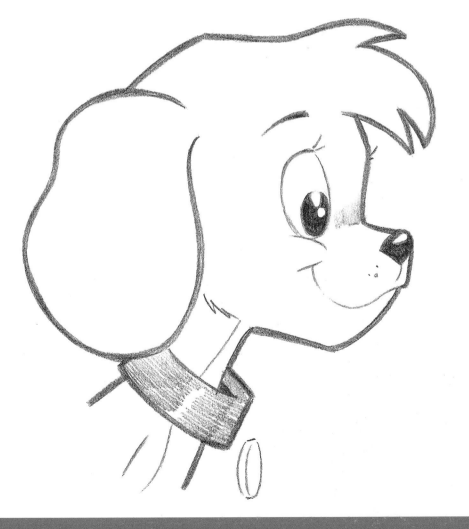

THE BODY FROM THE SIDE

Drawing a dog standing on all four legs isn't difficult in the side view, but you have to simplify it. The torso, for example, is one easy-to-draw shape. The dip in the back is necessary, as it adds the cute component to the posture. It's what causes the tummy to round out below. A straight back saps the exuberance from a pose.

And continuing our theme of simplification, the legs especially have been simplified to streamline some of the twists and turns of true animal anatomy; basically, some of the more complex joints have been eliminated. Note, too, the large head-to-body ratio. Give this shaggy pup a try. You'll be surprised how simple it is by merely following a few simple steps.

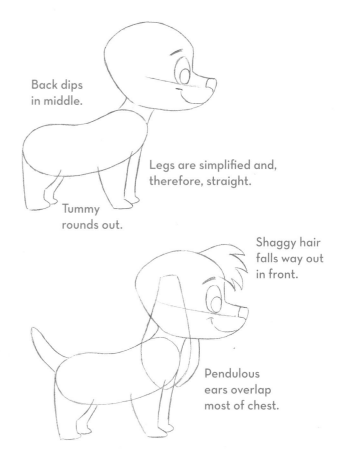

Back dips in middle.

Legs are simplified and, therefore, straight.

Tummy rounds out.

Shaggy hair falls way out in front.

Pendulous ears overlap most of chest.

A Note about Nose Placement

The edge of the nose usually aligns with the bottom of the eyes. This is a great method for checking the alignment of the features of the head in the side view.

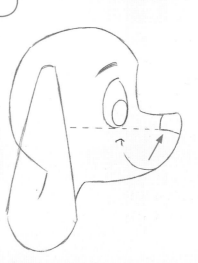

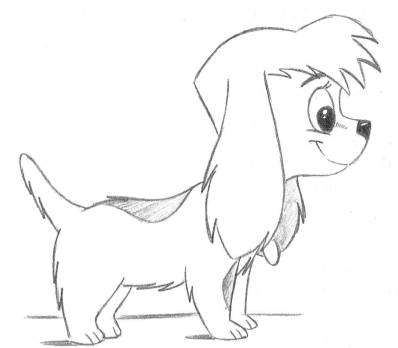

Ear Types

One of the first things I do when creating a cartoon dog is play with the ear type. It's much more important to the overall look of an animal than it is to a person, where ear shape is largely insignificant as it relates to character design. By merely changing the style of ears, you can greatly alter the look of the dog, even turning it into a different breed entirely. The the right are some popular ear types that are interchangeable on most generic cartoon dogs. But if you're drawing a specific breed, then you must use the ear type that corresponds to that breed. For example, a terrier cannot have pendulum-type ears but instead must be drawn with small, triangular ears.

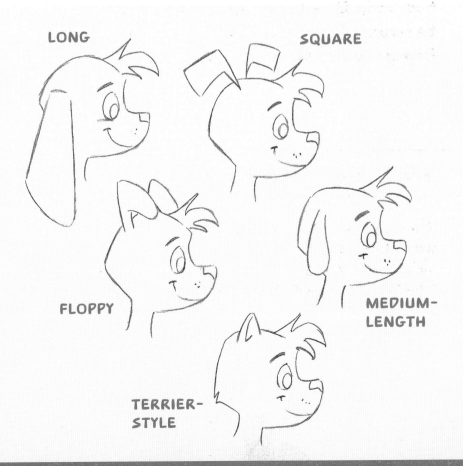

LONG

SQUARE

FLOPPY

MEDIUM-LENGTH

TERRIER-STYLE

WALKING THE DOG

To show a lively, bouncy walk, lift one front leg and one hind leg on the opposite side of the body high off the ground at the same time, and keep the chin up in the air.

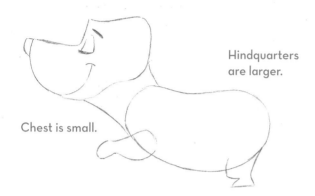

Hindquarters are larger.

Chest is small.

Nose extends past outline of head and is stuck on, like a knob.

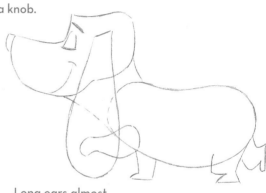

Long ears almost brush ground.

Tiny paws.

Cute Cartoon Flews

The first version shows the way realistic flews (or cheek flaps) are drawn. The second version is the way we simplify it, which makes it look cuter.

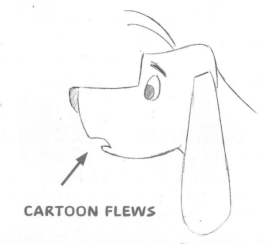

REALISTIC FLEWS

CARTOON FLEWS

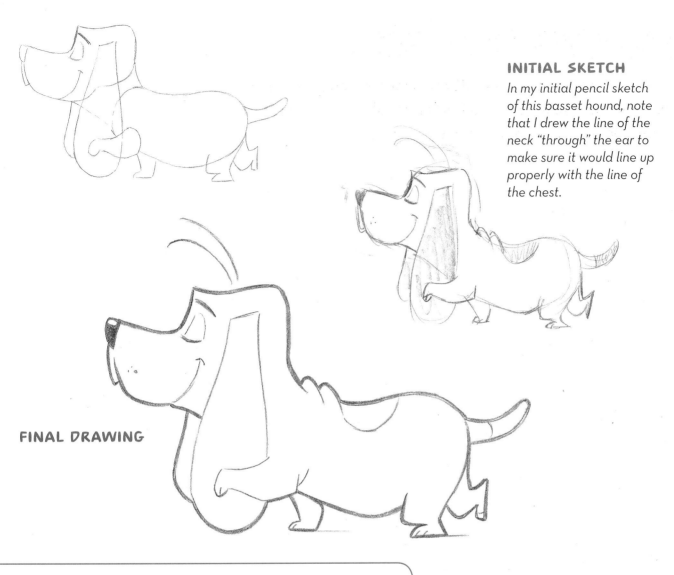

INITIAL SKETCH

In my initial pencil sketch of this basset hound, note that I drew the line of the neck "through" the ear to make sure it would line up properly with the line of the chest.

FINAL DRAWING

He Ain't Nothin' but a Hound Dog

This particular dog is a hound type. Hounds are noted for their flews—those big flaps that hang over the lips. This one is a basset hound, a naturally chubby breed with ultra-short legs and a husky torso. Because of its short legs, the tummy almost brushes the ground. Draw the torso so that the chest is slightly smaller than the rump. You don't want to draw dogs too "chesty," as that makes them look tough, not cute. The exception to this rule is the puppy bulldog, which we'll get to next. The muzzle is usually long on hounds, unless they're pups, in which case the snout hasn't had time to grow to its full length. And remember that contrast makes things cute. In keeping with this concept, make the feet tiny to contrast with the sizable body. Another thing to keep in mind about the basset hound is that its neck is always quite thick.

THE BODY IN 3/4 VIEW

Remember that in the 3/4 view the far legs will have to be drawn shorter than the near legs, due to the effects of perspective, which dictate that objects farther away from us look smaller.

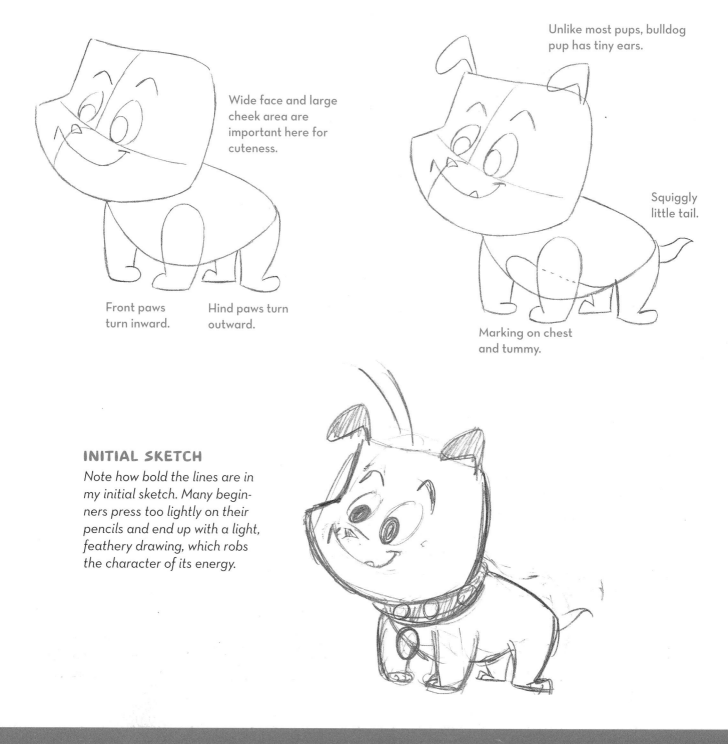

Wide face and large cheek area are important here for cuteness.

Front paws turn inward.

Hind paws turn outward.

Unlike most pups, bulldog pup has tiny ears.

Squiggly little tail.

Marking on chest and tummy.

INITIAL SKETCH

Note how bold the lines are in my initial sketch. Many beginners press too lightly on their pencils and end up with a light, feathery drawing, which robs the character of its energy.

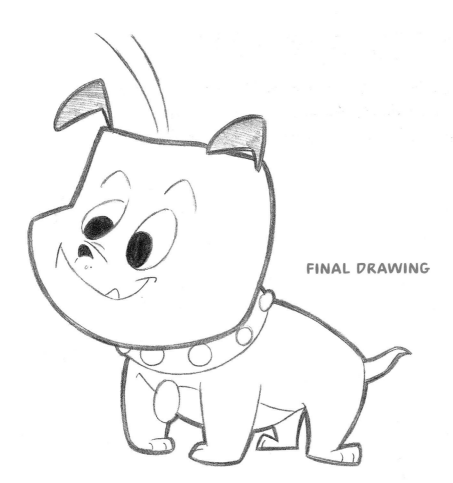

FINAL DRAWING

The Bulldog

Even toughies can be cute. Bulldogs used to be cast as villains in cartoons, but that has now changed. They're currently cast in the "big buddy" role more often than the villain role. So, how do you make them look cute? By making them look young, with affable expressions. To do that, give them a giant head and an ultra-tiny body. Big eyes, which adult bulldogs do not have, are used for the puppy version. Most cartoon bulldogs have giant chins, but you should underplay it here to make the character look cute.

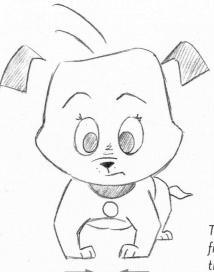

This is the classic front-paw position for the cartoon bulldog.

SEE SPOT SIT

To explore the sitting pose, let's start with this itty-bitty puppy. This drawing is all about contrast—contrasting sizes and shapes. Parts of this dog are gigantic, while others are diminutive. It makes a funny-looking combination, but more than that, it makes him look dear. This is also a good example of combining shapes to create a character. The head is a perfect oval, and the body is based on a triangle. Put together, the head looks like it's teetering on the point of the triangle, which makes him look slight and somewhat fragile—the perfect combo to evoke sympathy in a reader.

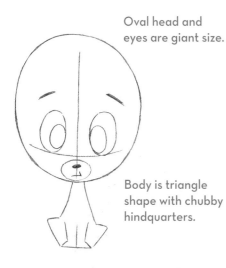

Oval head and eyes are giant size.

Body is triangle shape with chubby hindquarters.

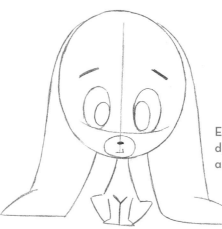

Ears don't go straight down but spread out as they hit ground.

Feet are hidden under "bunched" hind legs.

It's All about the Y

Look for the Y on the front of the torso in all front-view poses in which the legs are together. This occurs in many animals, such as lions and cats, as well.

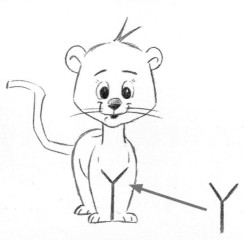

Super-Exaggerated Small Characters

With super-small characters, greatly simplify the features. The result is a totally winning character type. Super-exaggerated, miniature characters like this one below borrow their proportions from chibis, those ultra-cute characters from *manga* (Japanese comics). So, their heads balloon up to a giant size, and their bodies shrink down to almost nothing, with little limbs that taper so much that their hands and feet become practically nonexistent. Like the result? It's appealingly retro.

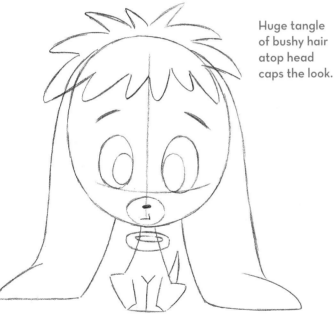

Huge tangle of bushy hair atop head caps the look.

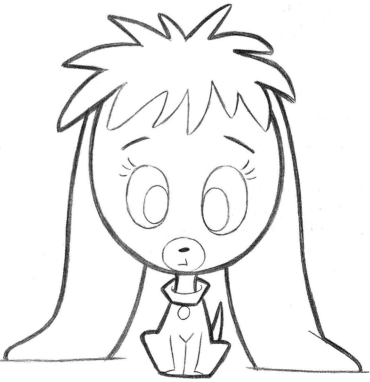

Side View Sit

In the side view you can really see that dogs lean forward, in the direction in which they're looking, always with a curious expression, whether they're happy or downtrodden. This doggy's expression is one of slight concern, and therefore, the back is drawn hunched. Also note that in the sitting position, the front legs are generally drawn inside of the hind legs, not outside, and are tucked close to the body.

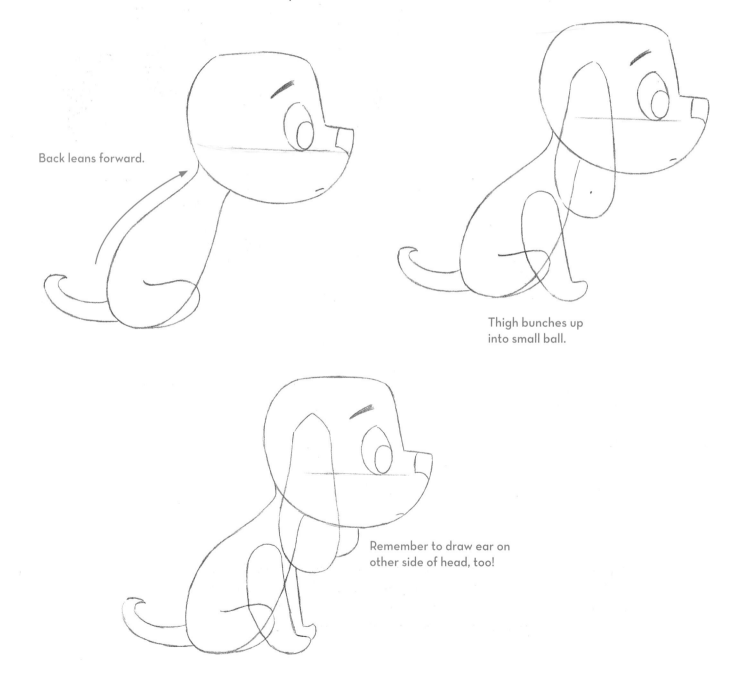

Back leans forward.

Thigh bunches up into small ball.

Remember to draw ear on other side of head, too!

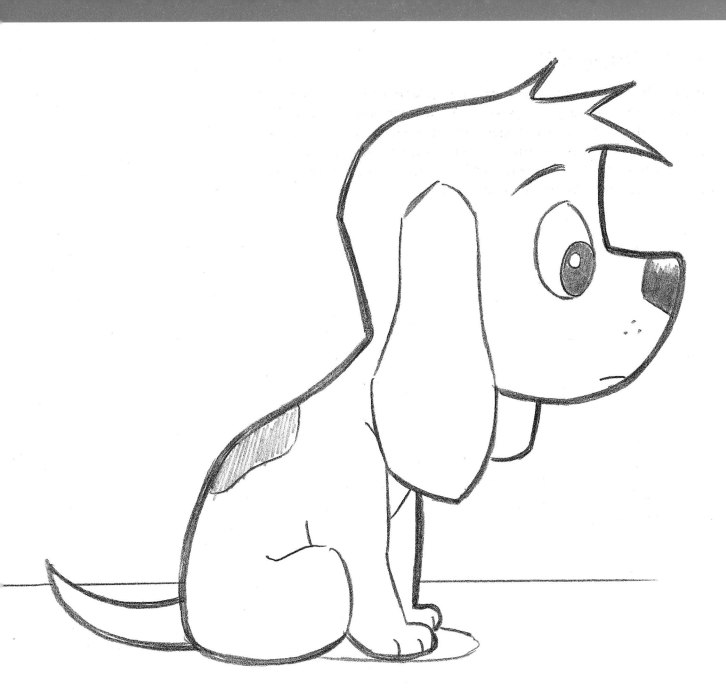

H!NT A random spot here and there is a good way to introduce markings. Many dogs also have "freckles" or smaller spots on the face. These don't work so well in cartoons, as they tend to clutter the image with distractions.

3/4 View Sit

This dog has an arched back, excitedly anticipating something good. But real dogs can't sit like this. Their backs are always hunched in the seated position. Nonetheless, the arched back is such an accepted convention, connoting joy, that we break the rules a bit and use it anyway. When a dog sits, the chest sticks out and the bottom widens. Place both front paws side by side, in a dainty manner.

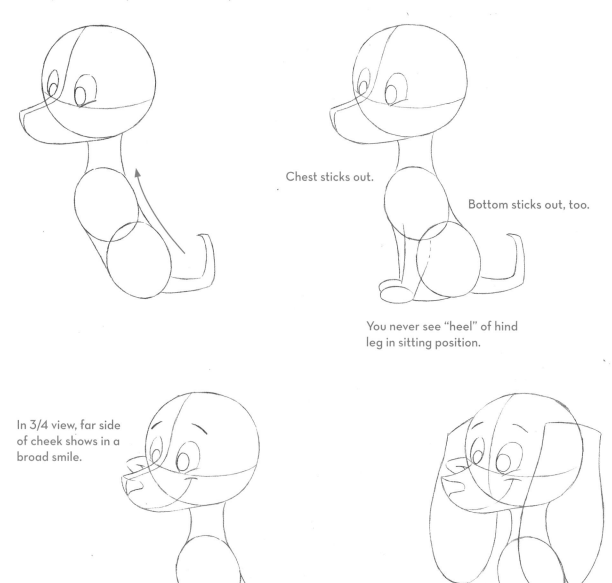

Chest sticks out.

Bottom sticks out, too.

You never see "heel" of hind leg in sitting position.

In 3/4 view, far side of cheek shows in a broad smile.

Flatten ledge at top of giant ears.

Body & Tail Posture

When real dogs sit, the back hunches convexly. But in cartoons, this posture can be read as sadness, worry, surprise, or wonder. The back of a happy sitting cartoon dog will have a more concave curve, which you can see in the steps opposite. In addition, the tail is a communicator of a dog's attitude. The sad dog's tail lays flat on the ground. The happy dog's tail curls up.

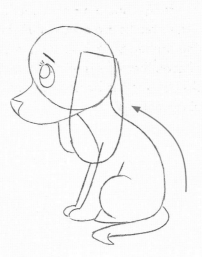

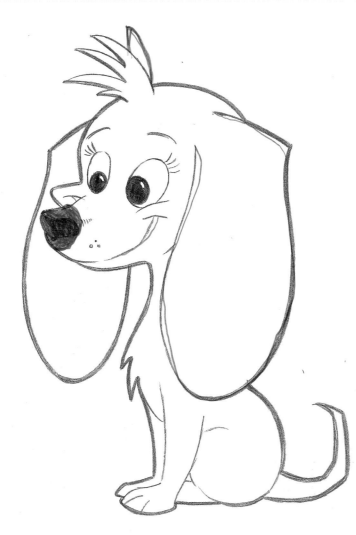

SEE SPOT STAND

It's cute when a pup drawn to stand on all fours tries to balance on two legs—especially if those legs are way short. I've eliminated the paws altogether on this pup, because they're not necessary. And the arms are too small to support them anyway. These pendulum ears are full length (the size you'd see on a regular-size dog) and narrow, to contrast with the wide head. Remember that contrast makes for good character design. That's also why we combine giant eyes with a teeny nose and a lean body with an oval head.

Head is oval—and large in back and narrower in front.

Torso leans forward to show some action.

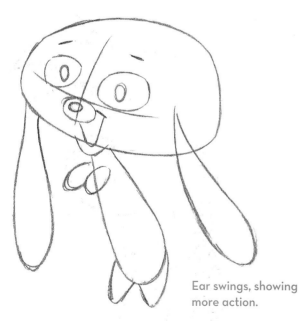

Ear swings, showing more action.

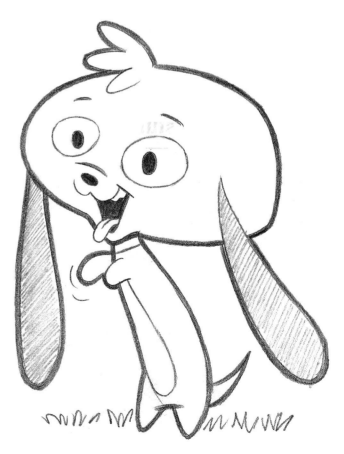

A Dog with Pockets?

Hey, it's a cartoon! You can do anything you want. Pockets on animals are one of those funny "reality breaks" that audiences love. Simply draw a line on the thigh and it becomes a pocket. Remove the hand from the pocket and the line of the pocket should disappear. But, of course, you've got to have an anthropomorphic animal—one that stands with human posture—to do it.

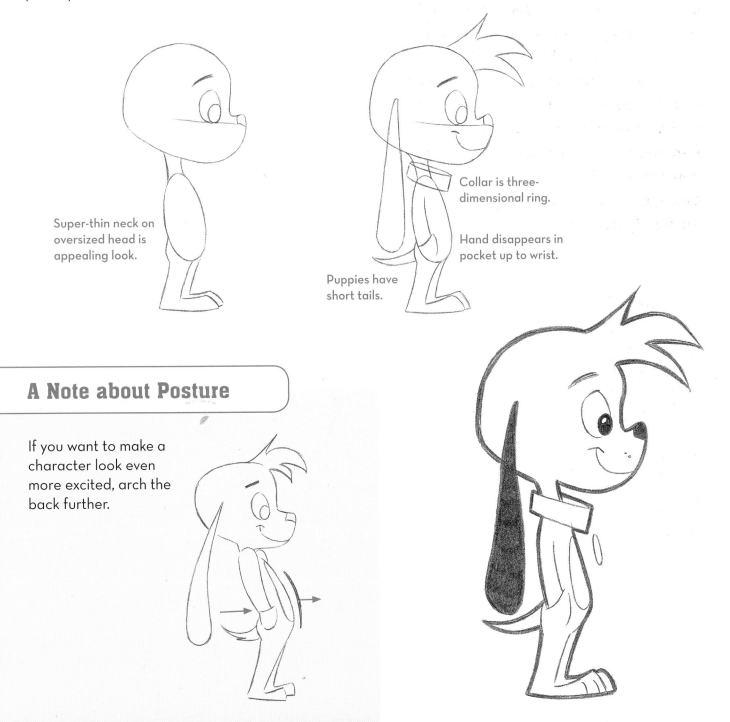

Super-thin neck on oversized head is appealing look.

Collar is three-dimensional ring.

Hand disappears in pocket up to wrist.

Puppies have short tails.

A Note about Posture

If you want to make a character look even more excited, arch the back further.

CAT BASICS

Only cartoon cats approach dogs in terms of popularity in animated TV shows, films, and comic strips, and some might argue that they actually surpass them. Since cartooning is based on exaggeration, we cartoonists can take certain liberties when drawing cartoon cats—just as we do with dogs. Therefore, to enliven their personalities, we like to infuse a little bit of "kitten quality" even in the full-grown cats, to make them more people-friendly—because, as everyone knows, cats can be pretty aloof. This is not to say that wicked or aloof cats aren't funny, but they're a little less cute, squeezable, or adorable. Still, the fact that cats are fluffy, and not bony, gets us closer to our "cute" goal.

Cat proportions feature big eyes and small noses, and this is helpful in creating appealing characters because of the size contrast. Cat heads are noted for their wide cheeks, which often are drawn with fluffy points at the ends or instead are sometimes drawn fat and round, like this one here. They also have a small, cupped chin. It's important to indicate that on your feline characters.

Cats should appear round, without any hint of hard angles in the face or body. The body should appear soft and pampered, which is the way every cat I know wants to be treated!

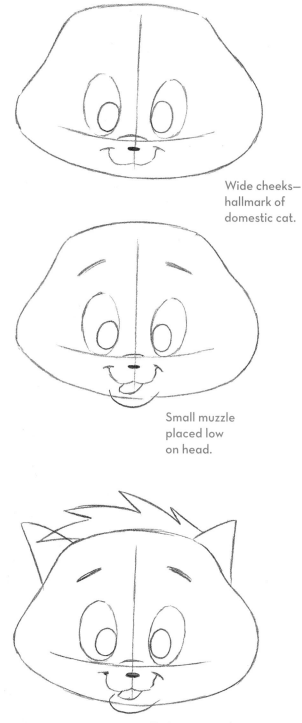

Wide cheeks—hallmark of domestic cat.

Small muzzle placed low on head.

Dainty, cupped chin—required on all cats and kittens.

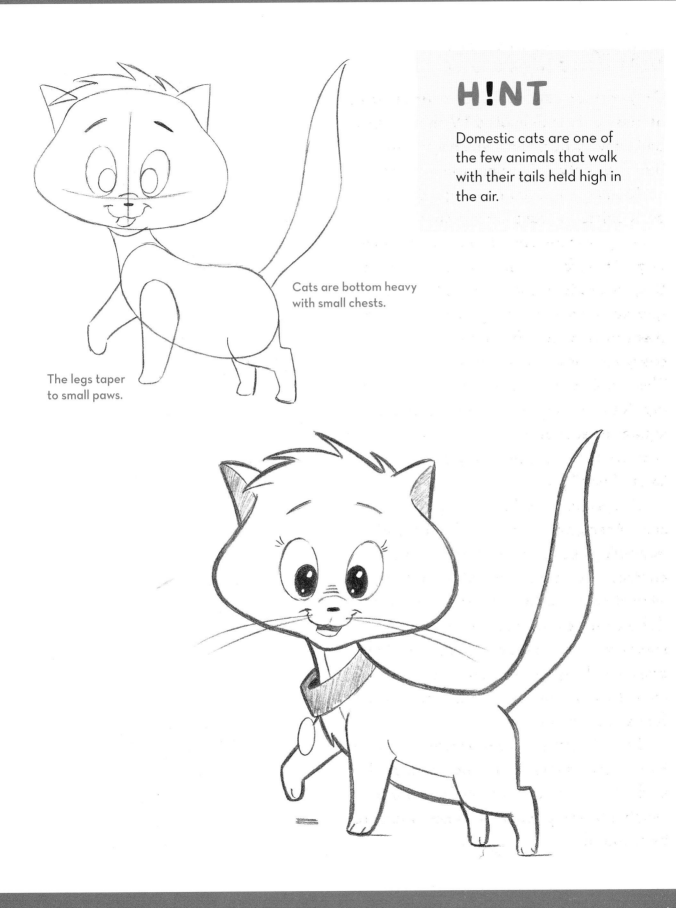

H!NT

Domestic cats are one of the few animals that walk with their tails held high in the air.

Cats are bottom heavy with small chests.

The legs taper to small paws.

ALTERNATE CAT BODY TYPES

Super-Exaggerated

A giant head on a teeny body results in an ultra-cute but incredibly silly type. These are extremely popular. Here is another almost American chibi-style cartoon animal. Its super-exaggerated head size makes it ridiculously cute!

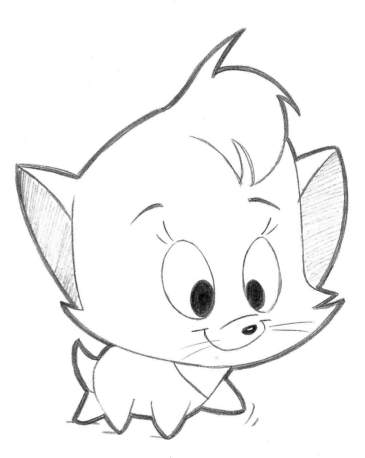

Lovable

This cute fluff ball is typical of cartoon kittens: a wide head on a chubby, little body. The eyes are spaced far apart, which is typical for youngsters. Note the oversized ears (it takes a while for the young cat to grow into them). It's also true that kittens have big paws, and you can give your kitten big paws if you wish; however, it also makes the animal look clumsy. I wanted this character to look sweet instead, so I purposely reduced the size of the paws to make them look delicate.

The body is small, compact, and based on an oval. The legs should be short and thick, because lovable characters are somewhat squat with extra padding on them to make them look squeezable. Cartoon kittens are often drawn with small, immature tails.

H!NT

Very little room is given for the chin on purpose. You don't want your cat to appear tough, which a big chin can do.

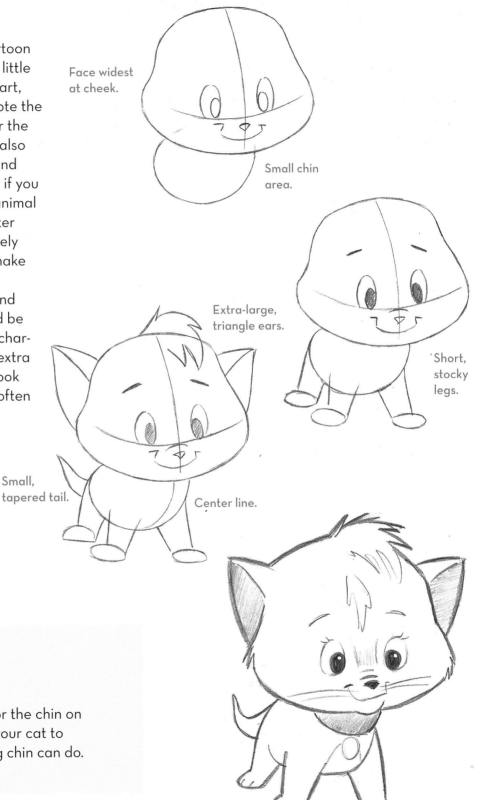

Face widest at cheek.

Small chin area.

Extra-large, triangle ears.

Short, stocky legs.

Small, tapered tail.

Center line.

CLASSIC STANDING KITTY

This youngster has a football-shape head on a small but plump body. The charm comes from centering all of the features in the middle of the face. For a youthful look, the muzzle is as far down on the face as possible, and the eyes rest directly on top of it. The head is so large, compared to the body, that a distinct neck becomes impractical; so instead, the head drops directly onto the torso, and we simply add a collar. The arms and legs are so short that they don't even show bends or joints in them. A short tail is accurate for kittens. Younger characters take shorter whiskers. Add some varying shades of pencil tone and you've got it.

Head shaped like American-style football.

Bend in back.

Protruding tummy.

Muzzle rests on bottom of face.

Short arms and legs.

No Neck vs. Showing the Neck

When you've got a huge head on a small body, it's often best not to show a neck at all. By looking at this examples, you can easily see why. The version without the neck looks natural, while the one with the neck looks like the collar is choking the poor little fella.

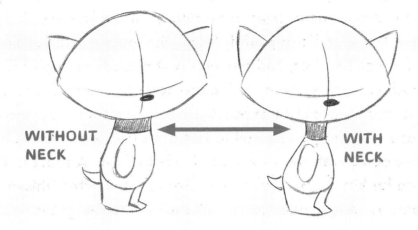

WITHOUT NECK

WITH NECK

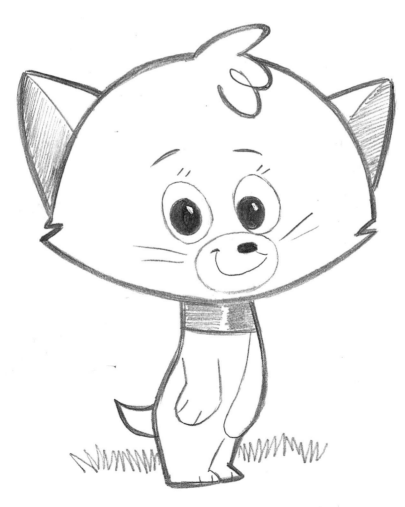

SITTING FUNNY

Cartoon cats can sit in humorous positions that no real cat can emulate. However, if a kid can do it, then your cartoon character can mimic it, because cartoon animals are really just furry kids. Note how we use the Y-shape divider on the chest to articulate the area where the forelegs and chest converge.

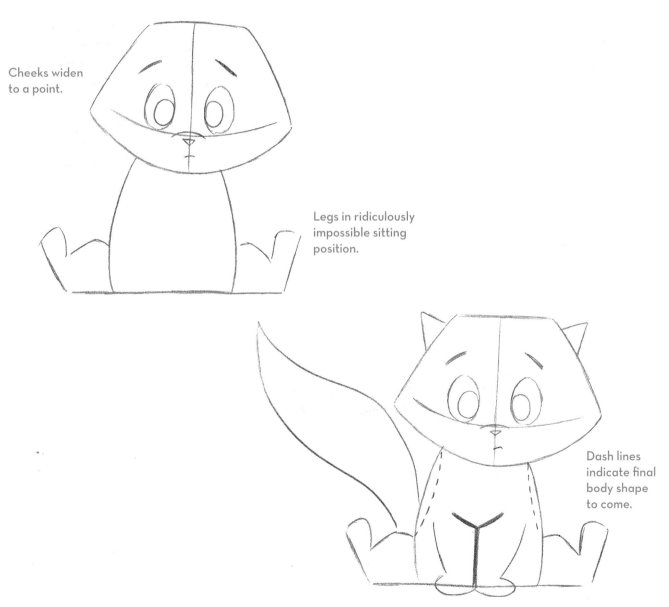

Cheeks widen to a point.

Legs in ridiculously impossible sitting position.

Dash lines indicate final body shape to come.

Y shape defines the chest/leg intersection.

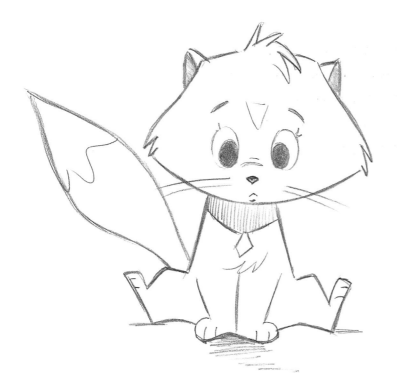

H!NT

In cartoons, whiskers do not originate at the nose itself but at the sides of the muzzle. Even though most animals have them, only rabbits, cats, lions, and tigers make a big deal of them by sporting long ones. Actual dogs have whiskers, too, but they're never drawn in cartoons. Chipmunks, beavers, and other woodland creatures sport short whiskers.

Nose Placement

Here's the difference in look and appeal between a nose placed in the middle of the face and one positioned low: The lower nose always conveys a cuter, more charming attitude.

Nose placed midway down face = not so appealing.

Nose placed low on face = more appealing.

Sinister Sitting

I couldn't resist it! I had to include at least one evil cat in the mix. They can be so deliciously diabolical when they simmer in sinister thoughts. Their faces scrunch up humorously toward the bridge of the nose, and the chin rises, too, pushing up on the muzzle as the eyebrows squash down on it. A sidelong glance under heavy eyelids reads as a sign of evil intent. And the introverted sitting pose conceals the kitty's true intentions. He gives nothing away.

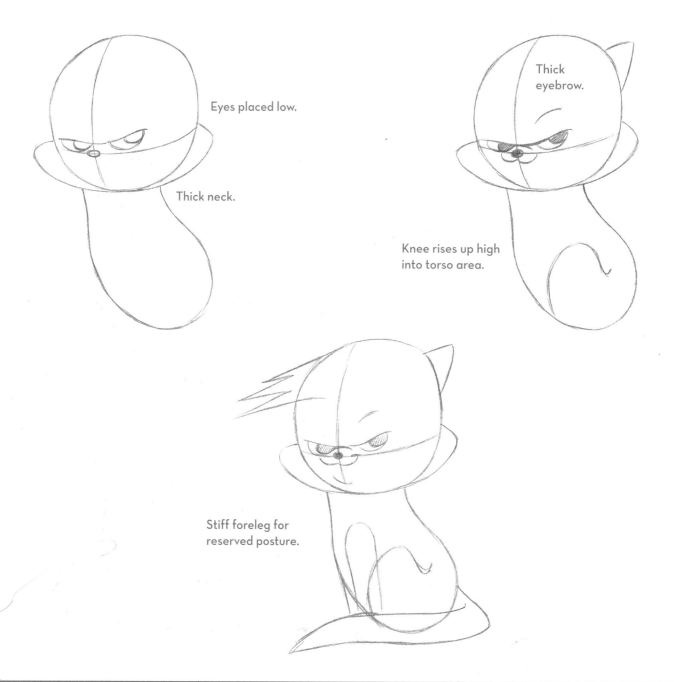

Eyes placed low.

Thick neck.

Thick eyebrow.

Knee rises up high into torso area.

Stiff foreleg for reserved posture.

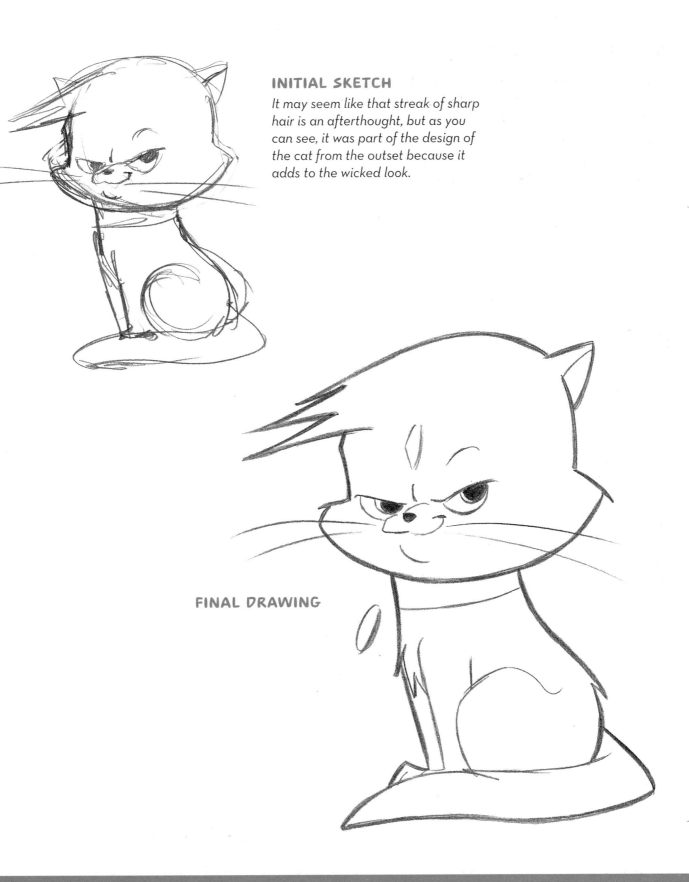

INITIAL SKETCH

It may seem like that streak of sharp hair is an afterthought, but as you can see, it was part of the design of the cat from the outset because it adds to the wicked look.

FINAL DRAWING

FEMINIZING ANIMALS

Feminizing animals to create female characters requires a few subtleties. The whiskers should be drawn wispy. The ears are small, even petite, and the tail is fluffy. Sometimes accoutrements are worn, such as ribbons, bows, flowers, hair clips, or fancy collars. But by far, the most important aspect of the head is the eyes. The eyes should be almond shaped and tilted up at the sides, with long, darkened lashes. The eyes are also often two-toned, meaning that the pupils and irises are different shades or colors.

Ears are small.

Eyes are almond shaped and tilted up at ends.

Paws are like mittens.

INITIAL SKETCH

As you can see from the shadow line, I originally was going to make this cat on the plumper side but ultimately decided against it.

Initial shape.

FINAL DRAWING

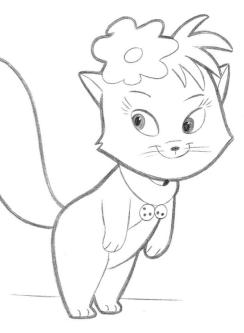

Detail: Female Cat Eyes

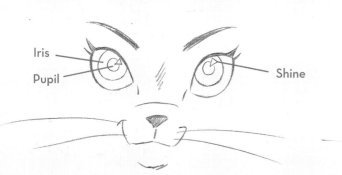

Iris

Pupil

Shine

SEMI-REALISM

This is a slightly more realistically drawn cartoon cat. Real cats have rather large ears, like these, with big empty "pockets" of space in them. The classic "cat eyes" here are almond shaped with large pupils. (On a real cat, the large part of the eye is the iris, and the pupil is only a slit.) And the bridge of the nose is more defined with a slightly elongated bridge. But the main thing that creates the realistic look here is the outline of the head, along with the more realistically proportioned body. Give it a try. It's not hard to do. Start the outline of the head with a circle; then build outward to include the cheeks and the chin.

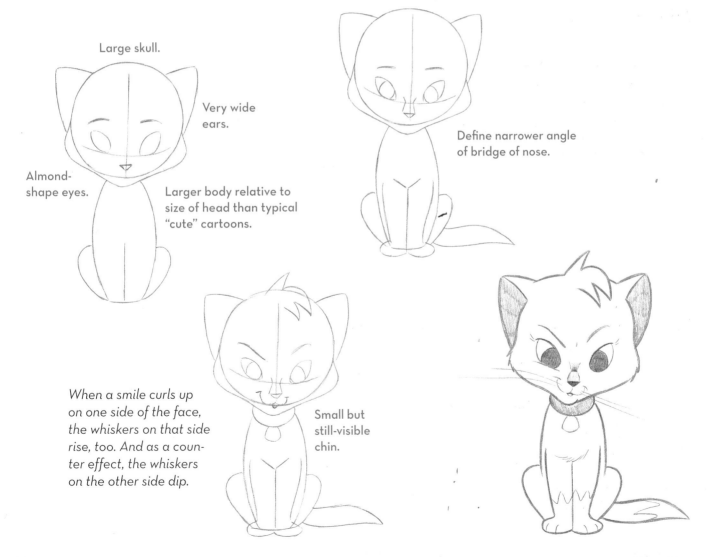

Large skull.

Very wide ears.

Almond-shape eyes.

Larger body relative to size of head than typical "cute" cartoons.

Define narrower angle of bridge of nose.

When a smile curls up on one side of the face, the whiskers on that side rise, too. And as a counter effect, the whiskers on the other side dip.

Small but still-visible chin.

3

Bears

Bears are so popular that they definitely warrant their own chapter. In children's book illustrations, bears perhaps surpass all other animals in terms of popularity. And they've starred in their own animated movies, as well. Fat and cuddly, bears have the ability to win the hearts of audiences and readers as few animals do. Maybe it's because their cartoon personas are generally jovial and fun-loving. Real bears have particularly wide faces and, believe it or not, long and pointy snouts. But to make them cute, cartoonists typically shorten the snout, making it less pointy. The eyes, which are quite small on real bears, are enlarged on the cartoon variety; however, the cartoon version maintains the thick and short legs of true bears. Bears also have large, round bottoms, which works perfectly for cartoons. Keep bears round and rubbery as they strike different poses. And note that many—if not the majority of—cartoon bears are drawn standing upright, like humans.

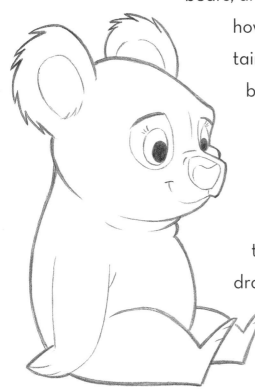

GIGGLING BEAR: HOW LAUGHTER AFFECTS THE BODY

There's plenty of shoulder action making this pose work. In cartoons, the body language of laughter is portrayed by drawing the shoulders shrugged up, with motion lines around them.

As to the bear basics: Bears have extra-wide heads. We can emphasize this by grouping all of the features together in the middle of the face, which makes the head look wider by contrast. The belly hangs over the waistline a bit, as bears are notoriously enthusiastic eaters!

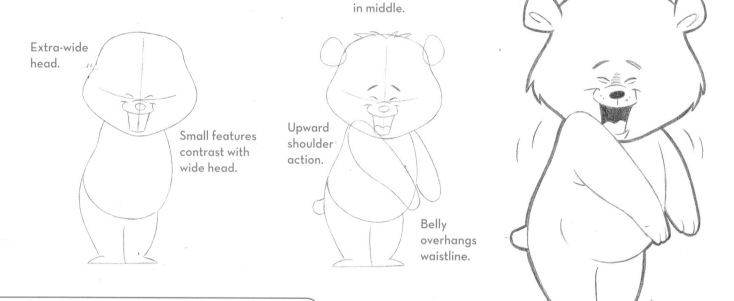

Extra-wide head.

Small features contrast with wide head.

Head indents in middle.

Upward shoulder action.

Belly overhangs waistline.

Why No Neck?

Note that the head shape overlaps the body shape, so we rarely see the neck on a bear. Instead, the head sort of sinks down into the shoulder area.

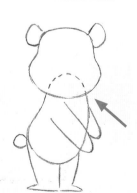

Like those of many other mammals, the bear's muzzle is based on an oval shape.

Laughter from the Side

The curved line of the back and the protruding tummy make the pose effective. Again, you can see how the features of the face take up only a small area of the bear's very wide head. And the snout, which is long and pointed on a real bear, has been clearly shortened and rounded off for the profile. Don't forget to use the shoulders to underscore the giggling action.

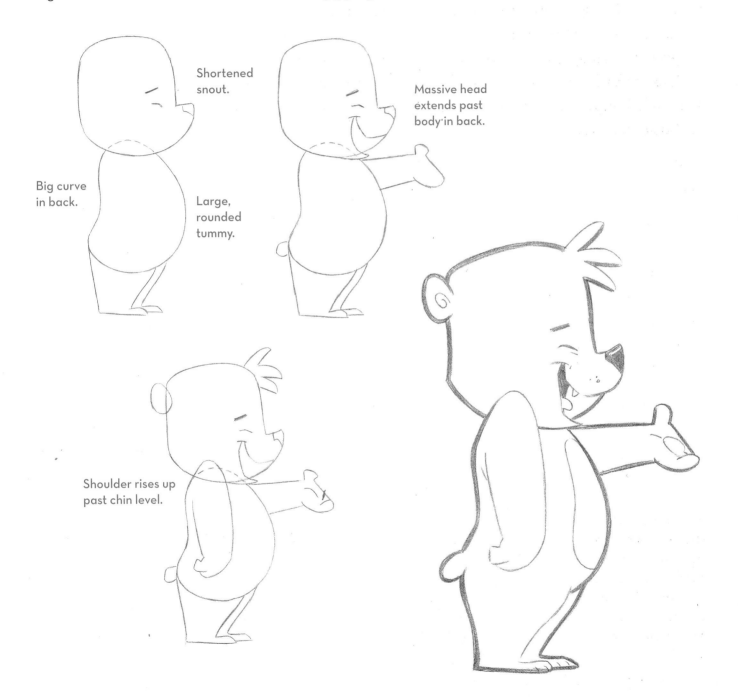

Shortened snout.

Big curve in back.

Large, rounded tummy.

Massive head extends past body in back.

Shoulder rises up past chin level.

CUB BODIES

Here's a little fella who's easy to draw, because he's practically all head with very little body. His body is short and shaped like a raindrop—in other words, cute! Like all cartoon babies (human and animal), his head takes up half the length of his body. The legs are spaced apart, giving him a slightly awkward stance—the type you see on human toddlers who have just learned how to walk. Keep the hands and feet small. The diapers need to be oversized to look funny, as if he's swimming in them.

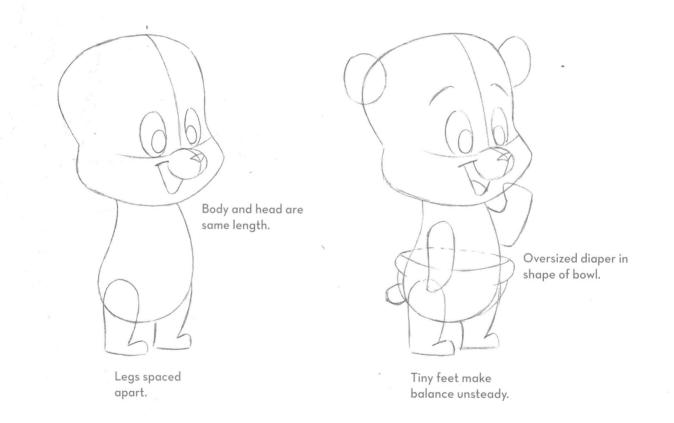

Body and head are same length.

Legs spaced apart.

Oversized diaper in shape of bowl.

Tiny feet make balance unsteady.

Drawing the Back of the Head

Either way shown here is correct; however, when characters are very young, I like to use the bumped-out method for shaping the back of the bear cub head.

STRAIGHT BACK

BUMPED OUT

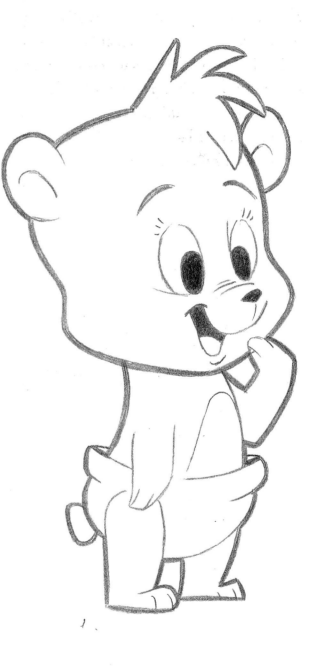

Walking Cub

Here's another cute cub who doesn't seem too sure of himself. He takes a fretful glance back as he steps forward. Note that both of his eyes tilt in the direction in which he's looking. This increases the concerned look on his face.

Instead of fingers, keep the individual digits melded together for a cute, mitten-type effect. The limbs are straight and not relaxed, for a toy-soldier sort of a walk— young and adorable. Try it and see how it works for your young characters.

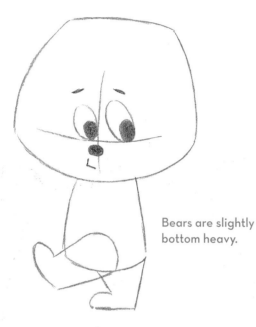

Bears are slightly bottom heavy.

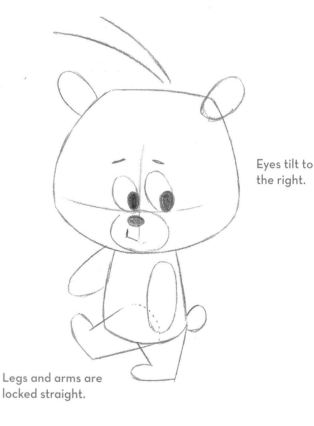

Eyes tilt to the right.

Legs and arms are locked straight.

Adding Subtle Appeal

A straight back is boring. Bump it out at the bottom.

STRAIGHT

BUMPED OUT

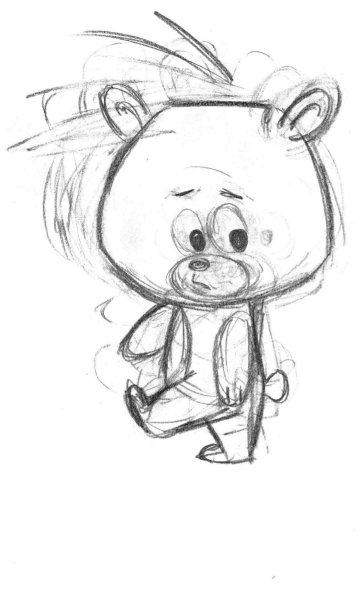

INITIAL SKETCH

Sometimes it takes extra work to make something look simple!

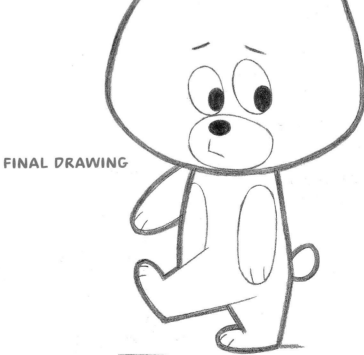

FINAL DRAWING

TRADITIONAL ADULT BODY

We've been drawing young bears up until this point. Now, here's an adult. Full-grown bears are rather tall standing up. Usually we draw a curved back, but on tall characters, you can also leave it straight; the taller the character, the less flexible the body becomes. When standing, all of the weight sinks to the lower half of the body, creating wide hips and a huge bottom, which only adds to the humorous appeal of the character. And just as with the youngsters, the legs remain short.

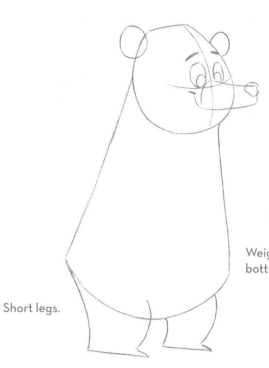

Weight sinks to bottom of figure.

Short legs.

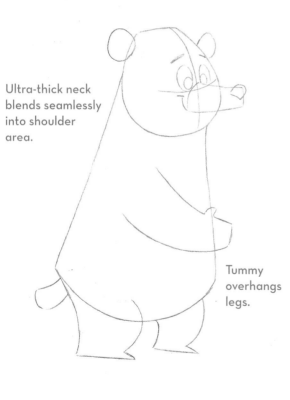

Ultra-thick neck blends seamlessly into shoulder area.

Tummy overhangs legs.

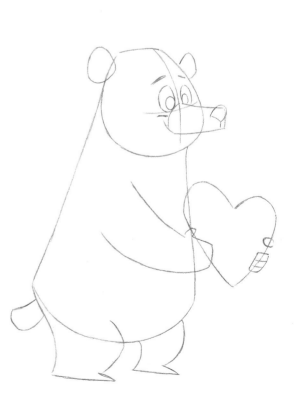

The Face Up Close

You can see that the snout is longer and sharper than it is on cubs. We offset this aspect of the adult bear by keeping the general head shape very round. Although the eyes are a nice size, they can't be as huge as they are on youngsters, because the forehead is smaller on an adult and can only comfortably accommodate medium-sized eyes.

The "in love" expression of this fella is best portrayed by enlarging the pupils but keeping the eyeballs the same size as they normally would be.

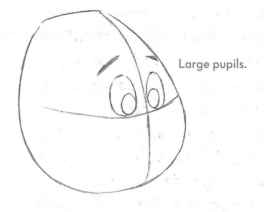

Large pupils.

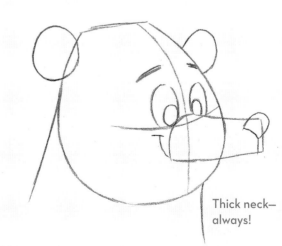

Longer snout with recessed chin.

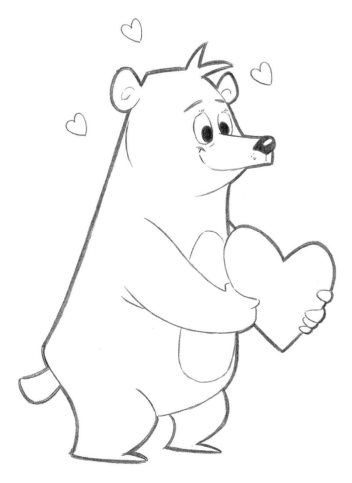

Thick neck—always!

KOALA BEAR

Koala bears are typified by their oversized ears (sometimes drawn fuzzy, too) and giant noses. To accommodate the very large, somewhat square nose, the muzzle is also a modified square shape. In addition, the koala has a plump, round torso. In fact, the torso should look like a football inflated to full capacity! The koala is often seen sitting rather than standing. The head is much larger, relative to its overall size, than the head of a North American bear, like the brown bear or grizzly.

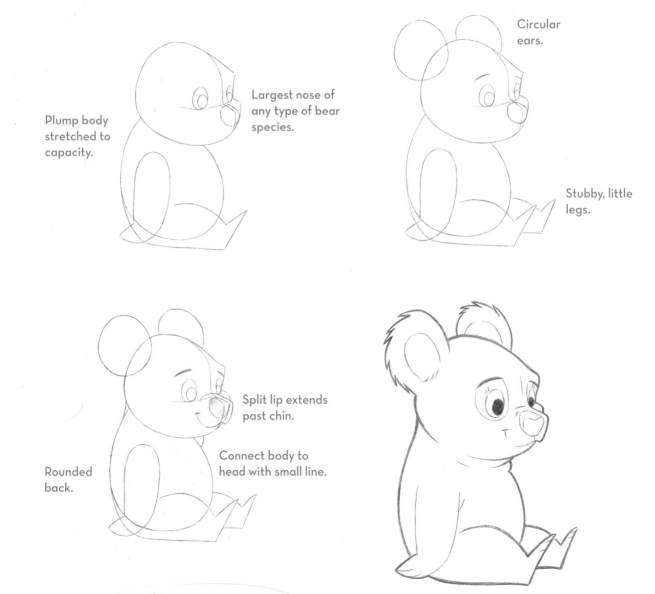

Plump body stretched to capacity.

Largest nose of any type of bear species.

Circular ears.

Stubby, little legs.

Rounded back.

Split lip extends past chin.

Connect body to head with small line.

PANDA BEAR

Everyone loves panda bears. Their markings are positively striking and are the same from panda to panda. These guys even "out-cute" teddy bears. The fur is always drawn as smooth, not ruffled, in cartoons because it's very short. The face is extra-wide and round on pandas. They have a particularly fat bottom, which they like to sit on for hours at a time, munching on bamboo. (Pandas spend most of their time sitting.) To give them that ultra-adorable look, I don't even bother to give them paws at all but just make the arms and legs chunky looking at the ends.

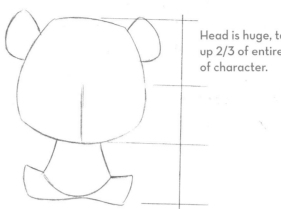

Head is huge, taking up 2/3 of entire size of character.

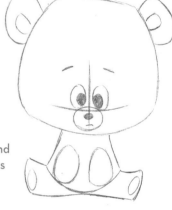

No paws; abrupt end to arms and legs, as on teddy bears.

Head Construction Hint

The head isn't built on a circle shape. As you can see, it's really based on a modified, or rounded, square.

Woodland
Creatures

Now let's roll out the rest of our forest friends. Most, though not all, of these guys are on the small side, but as you'll see, small cartoon critters have big personalities. These popular cartoon characters all live in North America in wooded environments. Some, like the moose, live all the way up north in Maine. Others, like the armadillo, roam further down south. Many of them—like beavers, skunks, and porcupines—venture out into campsites and even suburban backyards, where they get into humorous situations with cartoon humans. Some of these woodland species have starred in their own animated TV shows or movies; the other, more exotic types make great sidekicks.

CHIPMUNK

Due to their wariness of larger predators, chipmunks are bright eyed and always alert. Often they're portrayed as being hyper or nervous. In reality, chipmunks are amazingly fast and dart around like lightning! The chubby cheeks, fluffy tail, big buck teeth, and little rounded ears distinguish them from other woodland creatures. Cartoonists emphasize their roundness so that they look more like a plush toy than an animal! They're an audience favorite.

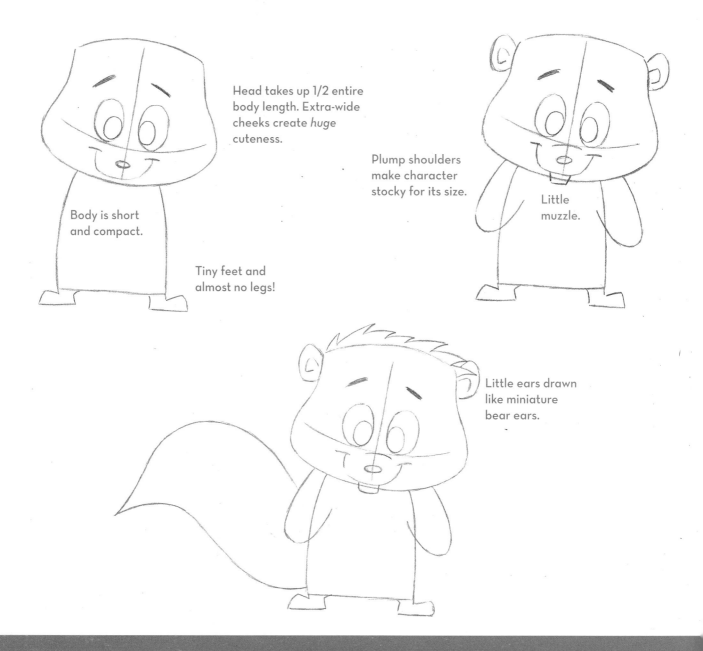

Head takes up 1/2 entire body length. Extra-wide cheeks create *huge* cuteness.

Body is short and compact.

Tiny feet and almost no legs!

Plump shoulders make character stocky for its size.

Little muzzle.

Little ears drawn like miniature bear ears.

The Details: Hands and Height

When you draw real hands and add extra height to little chipmunks, they take on too much of a human quality. Instead, keep them short, with little paws.

chippy

BEAVER

Beavers are the busy builders of the animal kingdom, always constructing dams and backing up water into everyone's backyard. They're usually depicted as either cheery workers or no-nonsense contractors. They have a chipmunk-type face but with a bulbous nose and, generally, small eyes. It would be fun to give beavers huge, puppy-dog eyes; however, beavers need small eyes to look like beavers. The rest of the facial construction, being round and chubby, keeps the character cute despite the smaller eye size. Like chipmunks, beavers also have wide cheeks to indicate the strong jaw muscles they need for chewing through wood. As to the body, the beaver has notoriously short arms and legs on a squat torso.

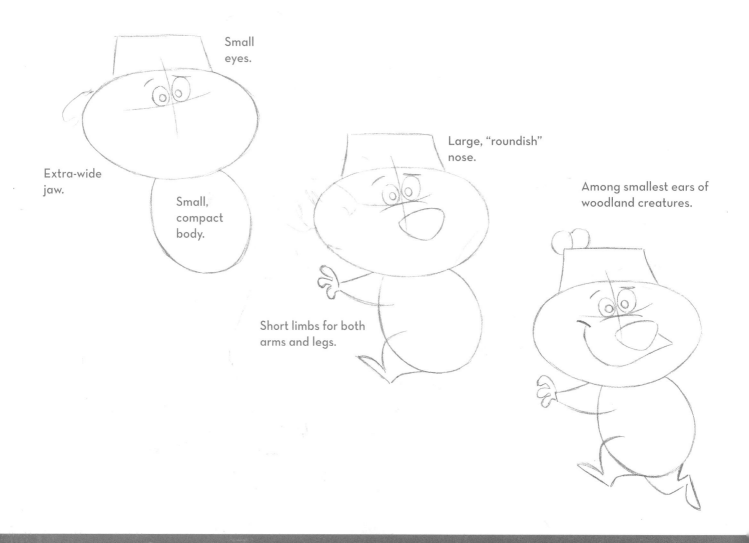

Small eyes.

Extra-wide jaw.

Small, compact body.

Large, "roundish" nose.

Short limbs for both arms and legs.

Among smallest ears of woodland creatures.

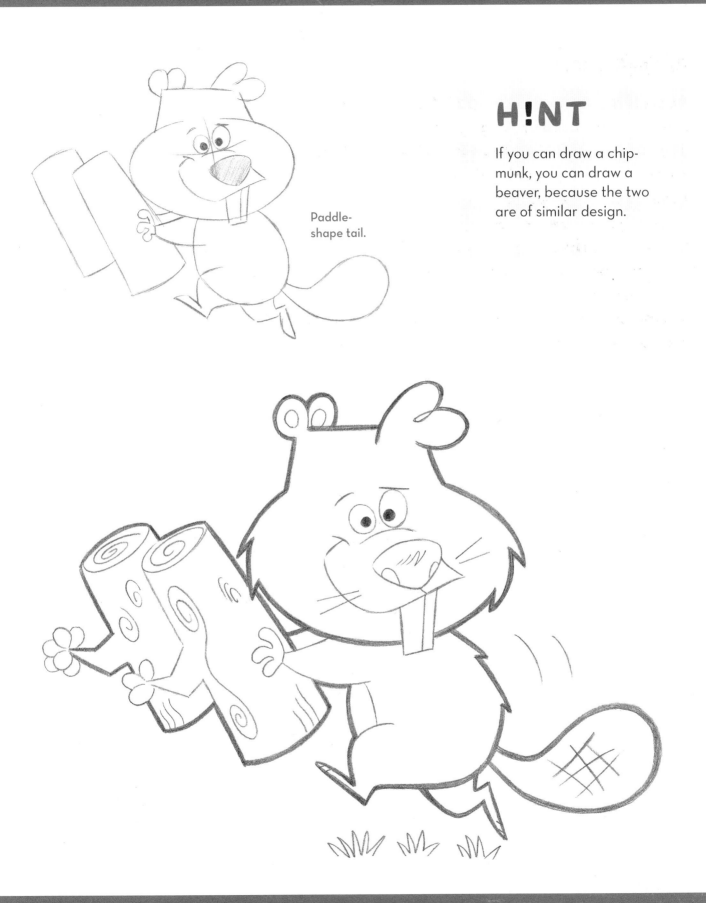

H!NT

If you can draw a chipmunk, you can draw a beaver, because the two are of similar design.

Paddle-shape tail.

Alternate Character Design: Big-Eyed Beaver

There are exceptions to the small-eye rule, when you can draw beavers with bigger eyes, but they can't be giant size or the character won't be recognizable as a beaver. The bigger-eye style necessitates a bigger head relative to the length of the body.

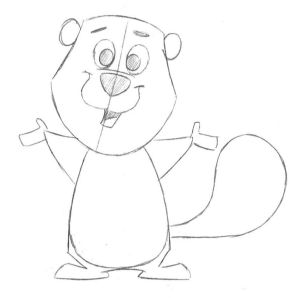
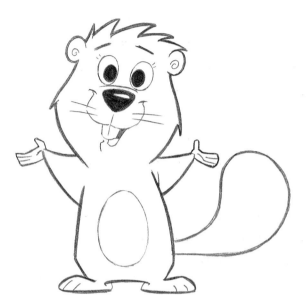

Buck Teeth

Here's a variety of different styles for those famously overgrown buck teeth of the beaver.

SINGLE WIDE TOOTH **DOUBLE "TOOTH"** **SPACED APART** **UNEVEN**

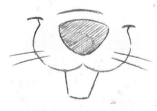
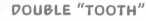
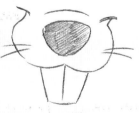
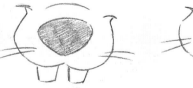

PORCUPINE

Porcupines may look huggable, but I wouldn't recommend actually hugging one. The thorny needles that surround the porcupine are called *quills*. When the quills stick an attacker, the quills come out, sticking in the attacker so that he gets a souvenir for his troubles but no porcupine. Our little woodland porcupine is, like all porcupines, just a friendly sort trying to mind its own business.

A member of the rodent family, the porcupine lives in a little den it creates in the ground. The cartoon porcupine should look like a squeezable doll, whose outline is surrounded by spikes. The character is always drawn on the plump side with very short legs, so the tummy brushes close to the ground and is, therefore, drawn flat, parallel with it. The back is always arched high in the middle.

High arch in middle of back.

Fat tail.

Pointy snout.

No quills on face!

Teeny feet, for cute look.

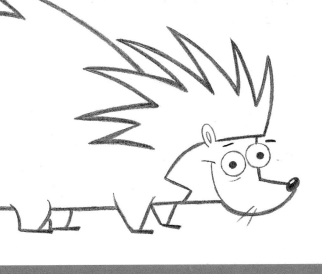

RACCOON

This little shoplifter will go through every item in your garbage can if you forget to close your garage door at night. Here he is, with the spotlight on him, afraid of being caught. The markings make him unique and memorable: a famous eye mask, blackened ears, blackened feet and hands, and rings around the tail. But the head construction is also special: The cheeks widen and come to a point, like those of a cat. But unlike the cat, the raccoon snout also comes to a point. The tail is quite long and fluffy. And the limbs are tapered and dainty. All in all, a curious and fascinating creature.

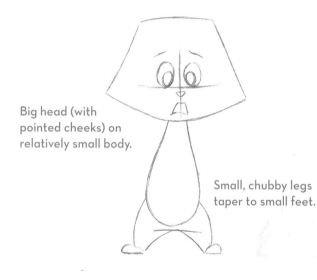

Big head (with pointed cheeks) on relatively small body.

Small, chubby legs taper to small feet.

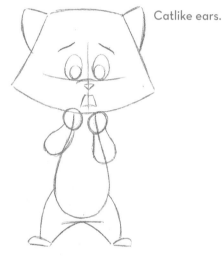

Catlike ears.

Popular Approaches to the Eye Mask

SEPARATED

CONNECTED

Raccoon "Hands"

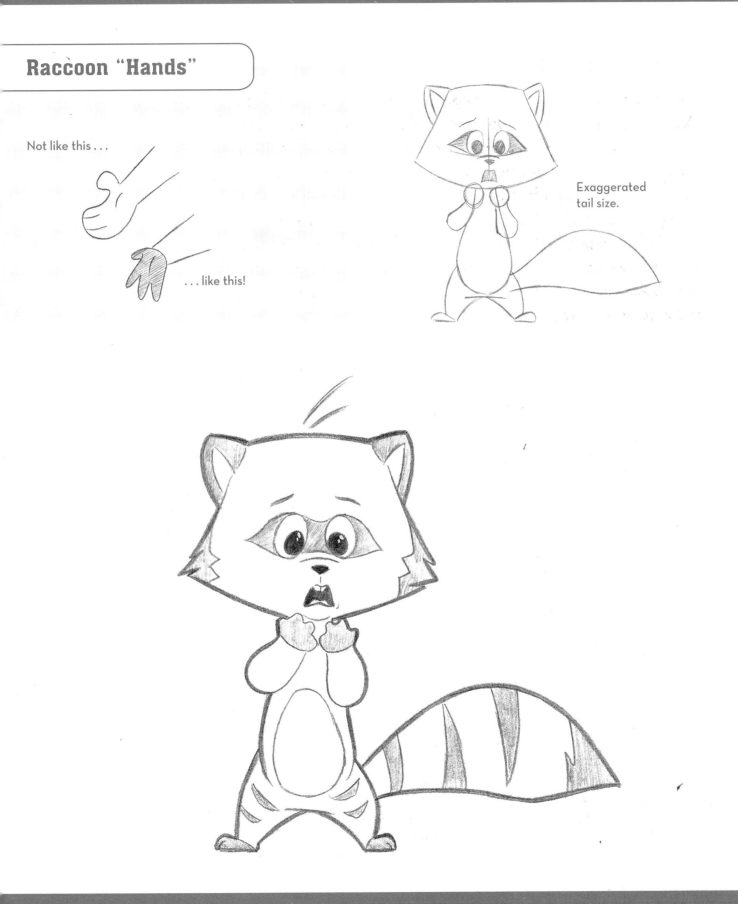

Not like this . . .

. . . like this!

Exaggerated tail size.

RABBIT

The key to drawing the bunny is "fluff." That's right, fluff. Fluffy body, fluffy head of hair, fluffy cheeks, fluffy tail—even fluffy-looking fingers! Rabbits always sport large buck teeth and bold whiskers. Rabbit feet are super-long, which is one of the bunny hallmarks. One of the special qualities a rabbit has is a pronounced split lip: The upper lip is divided into two rounded sections.

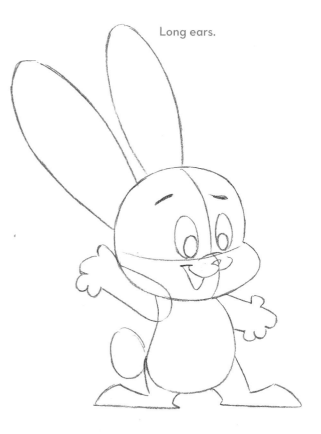

Long ears.

Split lip.

Even fingers are puffy!

Extra-long feet.

Ears

There are three ways to draw rabbit ears. Whichever you choose, be sure you're drawing them long enough. And make them thick, because you've got to leave enough room to draw the interior of the ears.

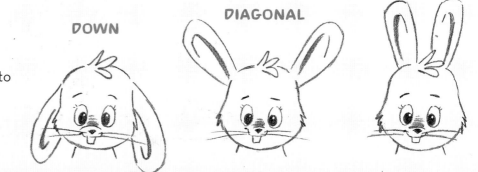

DOWN

DIAGONAL

STRAIGHT UP

Fluffy Tails

Tails can be drawn with a variety of different approaches for a stylish approach. If you draw two rabbits together, try to vary the tail styles, ear positions, and whisker types (see page 95) on each, to create individuals.

SPIRAL

SQUIGGLE

CLOUD

CIRCLE

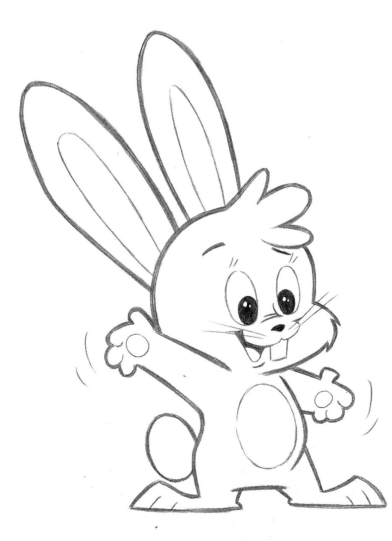

Alternate Character Design: Ears Down

This appealing character is drawn with the ears in the "down" position, which tends to emphasize the dear aspect of the rabbit; ears in the "up" position tend to reflect its perkiness. Again, notice the telltale split lip, which is a signature feature on all rabbit cartoons. And extra-large pupils give this little fella a winning smile. Rabbit cheeks bunch up, which is sort of a cartoon rule in character design—it heightens likability.

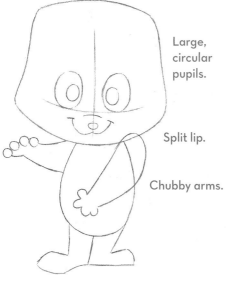

Large, circular pupils.

Split lip.

Chubby arms.

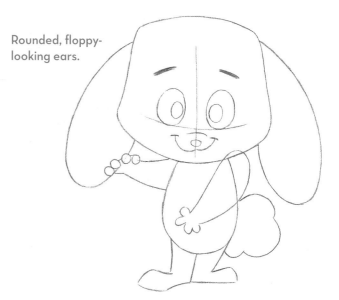

Rounded, floppy-looking ears.

H!NT

The temptation may be to draw the egg first and the rest of the body around it. Sure, that's easier, but your drawing will definitely look more accurate if you draw the entire body first.

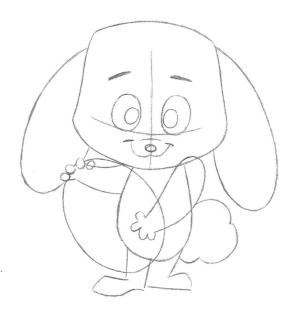

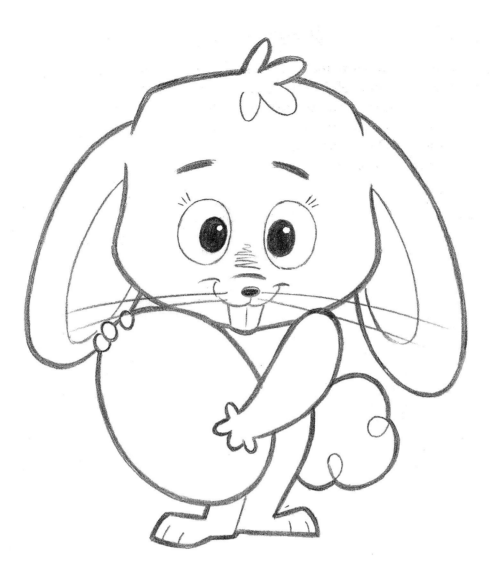

Whiskers

Here are the three main ways to draw cartoon whiskers. These varieties work on cats as well as rabbits.

RULER-STRAIGHT

SHORT

DROOPY

BADGER

Badgers are famous for their fighting spirit. You don't mess with a badger. They have interestingly shaped faces, with unique markings and pudgy bodies. Because of this, they make great cartoon characters. Here, we've eliminated the fighting aspect of the badger and instead emphasized the cuter traits. Badgers are best drawn on all four legs, because it shows off their long, horizontal bodies. Standing upright tends to make them look like very weird dachshunds. Don't want that. Badgers stand very low to the ground.

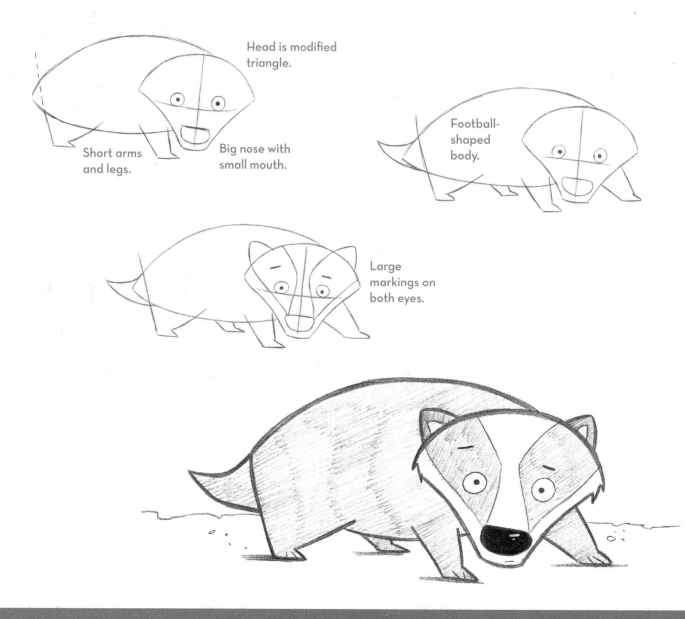

Head is modified triangle.

Short arms and legs.

Big nose with small mouth.

Football-shaped body.

Large markings on both eyes.

ARMADILLO

These little critters wear their armor on their head and back. They stand low to the ground, because they're diggers, searching the soil for grubs, beetles, and other insects. They are related to anteaters but are smaller, squatter, and much cuter—a better subject for the cartoonist's purposes. Real armadillos have small eyes and poor eyesight, but to make them cute, enlarge the eyes significantly. Also fatten up the face, which is in reality quite long and thin. Real armadillos have straight foreheads, but that's not nearly as appealing as a forehead that slopes downward to the bridge of the nose, as is the case here.

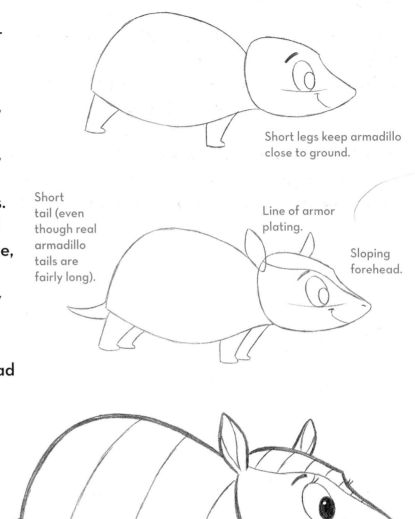

Short legs keep armadillo close to ground.

Short tail (even though real armadillo tails are fairly long).

Line of armor plating.

Sloping forehead.

How to Draw the Ear

SKUNK

The skunk makes an interesting cartoon character because of the problem that it poses: How does it deal with its own scent? Should it be oblivious to it or self-conscious of it? That's part of the fun—and for you to decide when developing your own character. This little guy seems to be unaware of it; meanwhile, we show fume lines emanating from the tail.

The most famous identifier of the skunk is the white stripe running down the length of the face, back, and fluffy tail. It's also a great design element that unifies the various components of the body.

Giant tail stands up vertically to look ready to give off scent at any time.

Head sticks right onto shoulder area without obvious neck (to keep things short and cute).

Stripe goes directly down forehead, right between eyes, to bridge of nose.

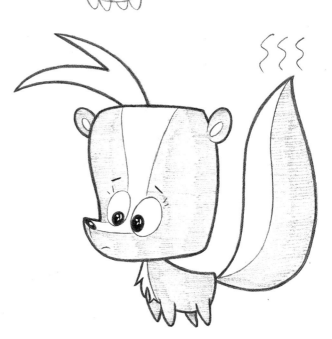

Paw Tip

Too much detail for such a simplified character.

More simplified— and better.

Walking Skunk

When you show an animal walking, it's generally most effective to draw two of its four feet off the ground at any given time. This gives the illusion that the animal is in motion. But naturally, both feet can't be off the ground on the same side, or the animal would topple over!

So what do you do? You alternate. And this is how: On one side of the torso, you draw the "foot" down and the "hand" up. Then on the other side, you draw the "foot" up and the "hand" down. Take a look at the second step, and you'll see what I mean.

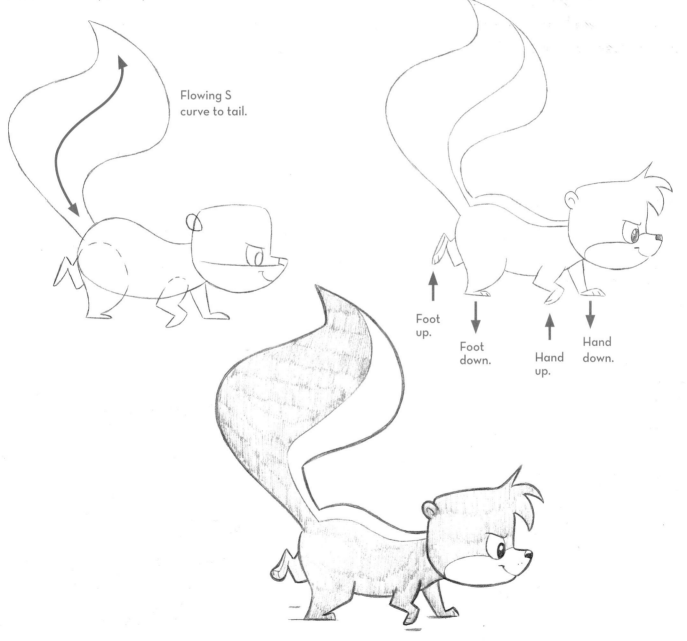

Flowing S curve to tail.

Foot up.

Foot down.

Hand up.

Hand down.

MOUSE

Mice are kind of jittery, always scurrying quickly to avoid everyone else since everyone else is bigger than they are! These nervous characters have been popular since the dawn of animation. Mice are drawn with a pleasing little tummy but never a big paunch. Their trademark features are giant ears, big cheeks, buck teeth, and a long, thin tail. In addition, we give them a few whiskers off the muzzle.

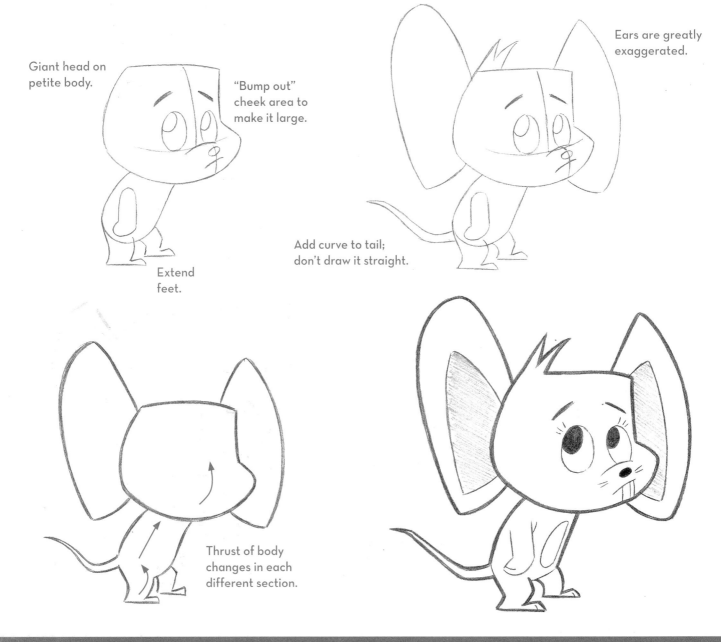

Giant head on petite body.

"Bump out" cheek area to make it large.

Extend feet.

Ears are greatly exaggerated.

Add curve to tail; don't draw it straight.

Thrust of body changes in each different section.

Alternate Character Design: Small Ears

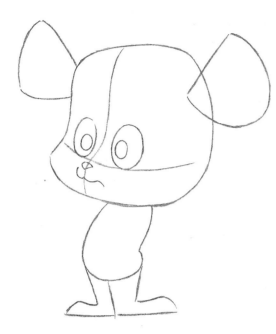

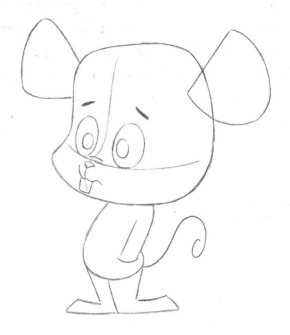

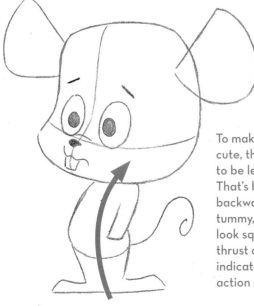

To make a standing pose cute, the character needs to be leaning—usually back. That's because leaning backward pushes out the tummy, making the figure look squeezable. Note the thrust of this effective pose, indicated by the line of action drawn through it.

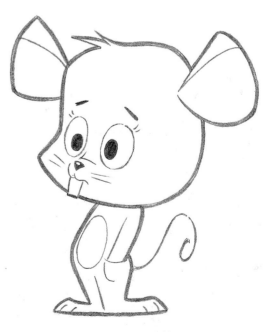

FERRET

Ferrets have actually been companions of humans for over several thousand years. They are gregarious playmates and fun-loving creatures. They're in the same family as weasels—but far cuter. Hyperactive and athletic, the ferret is an affable little fella. Like the raccoon, it has rings around its eyes, but its cheeks are not pointed, and it doesn't have rings around its tail. (Note the marking on the back and shading on the legs, however.) Its body is not squat and plump like the raccoon's, but sleeker and winding. Still, it could be confused for a raccoon if not for its long neck (raccoons have very short necks).

Low, flat forehead.

Extended neck.

Short, muscular limbs with tiny paws.

A line of action (an indication of the basic direction of the pose) is particularly helpful in drawing animals with long, sinewy torsos, as it maintains the flow of the pose.

FOX

Although they're nocturnal animals, foxes in cartoons are also depicted as day-time critters. They're clever, elusive, and fast. Real foxes have low foreheads, as do most mammals. But we increase the height of the forehead on our cartoon fox to make it appear younger and, there-fore, cuter. Big ears and a super-bushy tail give it that sought-after, squeezable look, even though foxes are athletically built. The dark markings on the paws and ears are essential. Likewise, always accent the tip of the tail with a white marking. Without these, your fox may be mistaken for a small coyote. Coyotes always play the bad guys in cartoons and are never thought of as cute. Also add markings on the chest and around the eyes; these are lighter than the body if you're shading or coloring your drawing.

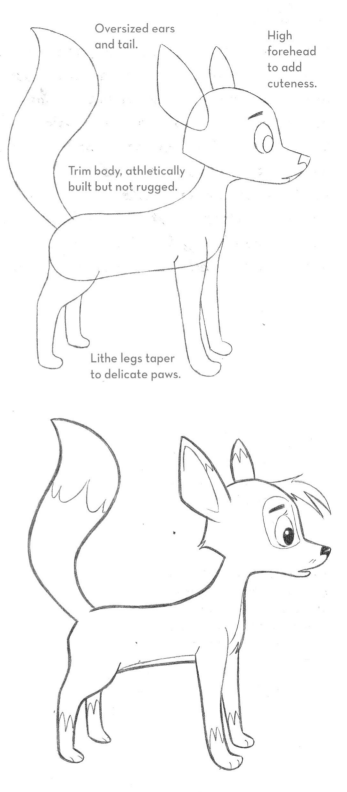

Oversized ears and tail.

High forehead to add cuteness.

Trim body, athletically built but not rugged.

Lithe legs taper to delicate paws.

Cartoon Silhouette Comparison

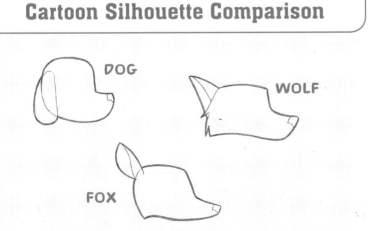

DOG

WOLF

FOX

WILD BOAR

The wild boar is more than simply a pig with tusks. It has a shaggy coat of hair, unlike its piggy counterpart. (True boars aren't really fat, but they're also not as appealing as their plumper cartoon version, so we pork 'em up.) While some pigs are drawn with short snouts, the boar is drawn with a long, prominent snout that makes it look wilder, less domesticated. Draw skinny legs for a humorous look and to contrast the overstuffed body, like an old, fat guy with spindly legs. Pig and boar faces have big cheeks, to make them look fat. And forget about showing the neck. This character's way too chubby for that. The head should look as if it has been fused directly onto the body.

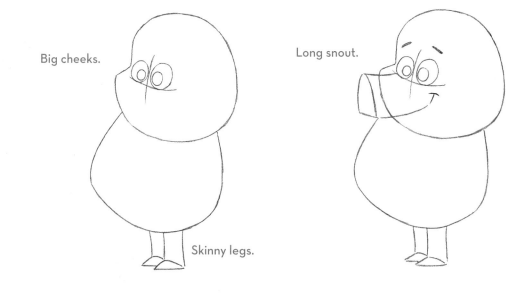

Big cheeks.

Long snout.

Skinny legs.

Leg Joints

Simplify the cartoon boar or pig's leg for a more fun look. Note that along with the simpler leg construction, the cartoon version shows the "heel" of the hoof touching the ground.

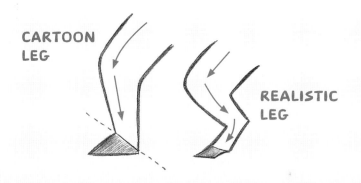

CARTOON LEG

REALISTIC LEG

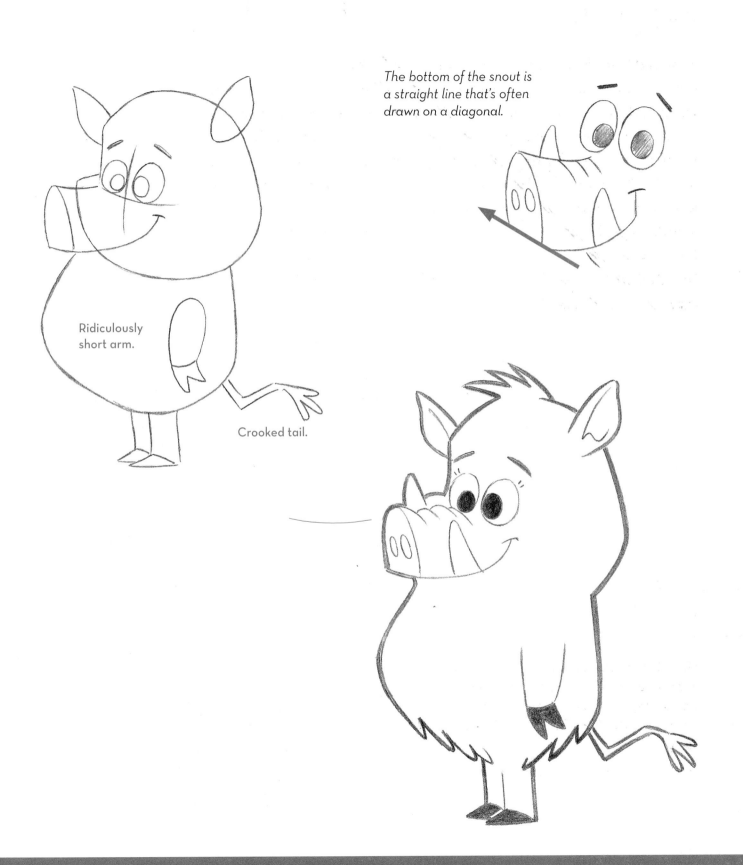

The bottom of the snout is a straight line that's often drawn on a diagonal.

Ridiculously short arm.

Crooked tail.

Pig Out!

Readers expect pigs to be cute because they're roly-poly by definition. I like to draw mine standing up, like chubby people, which I think gives them the most endearing look. Although we stereotypically think of pigs as fat, be sure to draw the body smaller than the head, which should be ultra-wide and have a big forehead. Yep, the pig's head is actually wider than its body in cartoons—it may be counterintuitive, but trust me, it will work.

The limbs should be short, which emphasizes the chunkiness of the body by way of contrast. Contrast is always a good tool to use in cartooning. Keep it in your arsenal of techniques! And remember: For the pig, the smaller the snout, the cuter the pig.

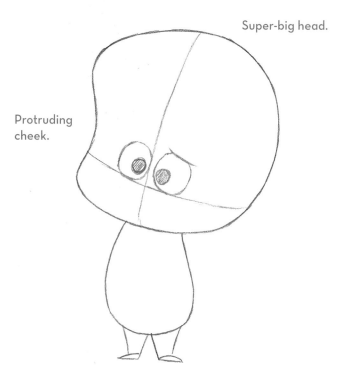

Super-big head.

Protruding cheek.

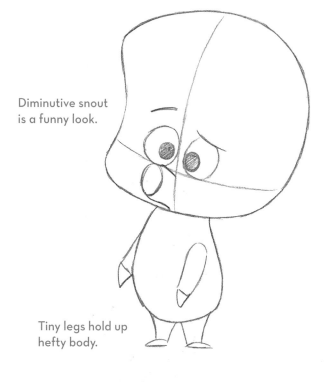

Diminutive snout is a funny look.

Tiny legs hold up hefty body.

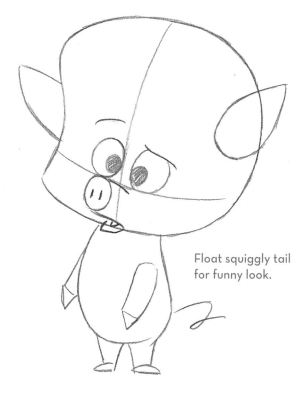

Float squiggly tail for funny look.

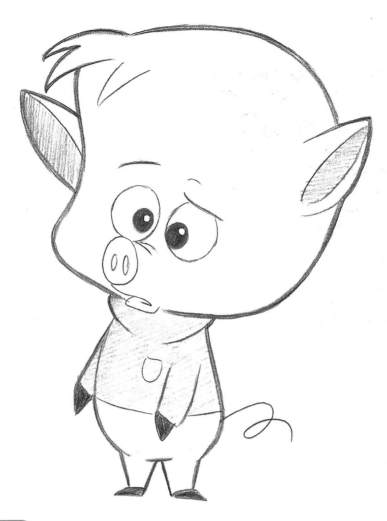

Body Gesture

A body that's round all over is uninteresting and static. For a more interesting pose, lean the torso in one direction by having one side round and the other angled toward the round side.

ROUND ALL AROUND

ROUND ONLY ON RIGHT

DEER

This young deer is all legs and very little body. Young deer have thin limbs. The legs are thin enough so that the joints in them look prominent. The hooves are always petite. On younger deer, the body is small and compact. As the deer gets older, the body lengthens.

To give a deer that sweet, charming look, make sure the part of the head that protrudes behind the neck is drawn large and round. The snout is small on the youngster. Draw bright eyes and erect ears for an always-alert expression. I have tons of fawns running through my backyard, and I'm always struck by how similar real deer look to their cartoon counterparts!

Posture Comparison

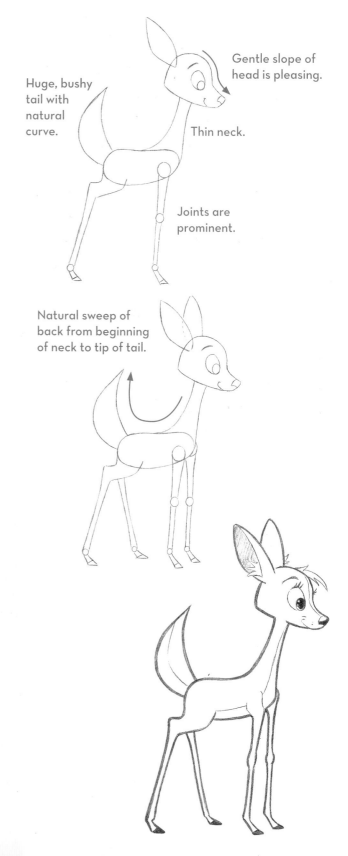

Gentle slope of head is pleasing.

Huge, bushy tail with natural curve.

Thin neck.

Joints are prominent.

Natural sweep of back from beginning of neck to tip of tail.

HEAD UP = WORRIED

HEAD FORWARD = CURIOUS

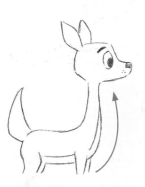

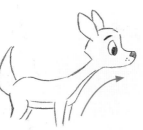

MOOSE

A moose with a Frisbee? Hey, why not? Although, it looks like he can't figure out whether to throw it or eat it. Moose can be big, intimidating animals. But when you stand them up, they become funny instead of menacing. Simplify the antlers (so that they don't overtake the rest of the drawing visually) by minimizing the number or prongs on each. But make them big, or your moose will look like a bizarre reindeer. Making things cute also requires shortening the naturally long "arms" and legs. Small hooves are funny. Look at that silly foot position, with both hooves pointed outward at a 90-degree angle. Now he's harmless! Draw an oversized head, with tiny ears for some contrast.

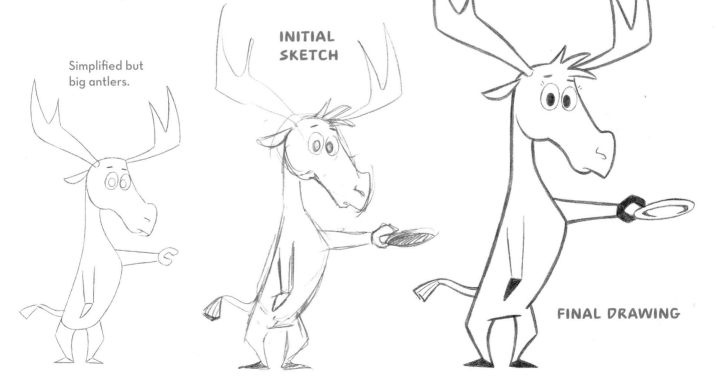

Bulbous nose.

Long body.

Simplified but big antlers.

INITIAL SKETCH

FINAL DRAWING

5

Animals of the Jungles & Plains

Many areas have plains, most notably Africa but also Australia and even America. The animals differ from plain to plain, however. For example, in Africa it's zebras, in America it's wild horses, and in Australia it's kangaroos. Then there are jungles, where many animals live in trees, like lemurs and some kinds of monkeys. Other animals live comfortably in both jungles and plains, such as lions and tigers. Most of the animals we'll cover in this section come from Africa, home of some of the largest and most spectacular land animals in the world. Included are not only the most popular animal types from TV and feature film animation but also the cool and exotic species that make great cartoons due to the weirdness of their character designs.

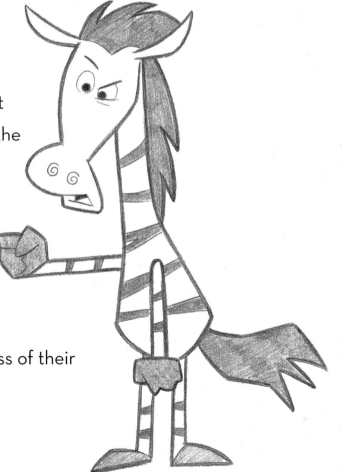

MONKEY

Real monkeys have small heads, but not in cartoons, they don't! The torso is generally reduced in size, but the head is enlarged, which makes them look like overgrown babies. However, the arms remain super-long compared to the diminutive body, which reflects an aspect of a monkey's actual proportions somewhat realistically. You can't go wrong drawing the arms too long, as they give the character its gangly look. The hands are oversized, as well, and the feet are flat, with the "thumbs" showing prominently. The legs, by contrast, are tiny, which isn't too far from the true anatomy of monkeys.

Monkeys have a prominent muzzle, which is delineated by a circular line drawn around the mouth. The eyes are big. The ears are enormous and set low on the face—always low.

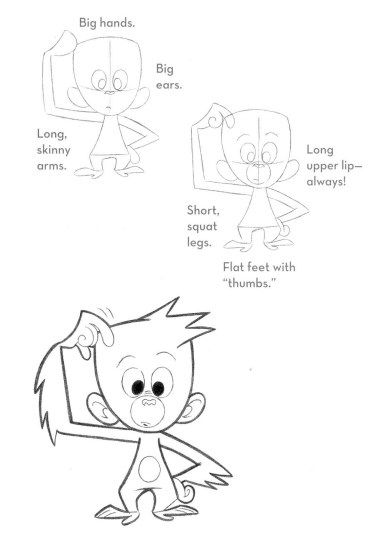

Big hands.

Big ears.

Long, skinny arms.

Short, squat legs.

Long upper lip— always!

Flat feet with "thumbs."

Monkey Proportions

Monkey bodies are two head lengths tall, which makes the monkey look short. The arm is as long as the entire length of the character!

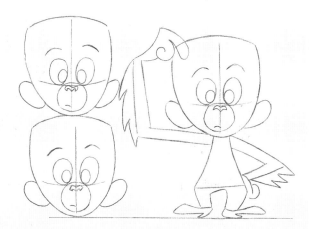

LEMUR

The lemur is a cousin of the monkey but a little lower down on the evolutionary tree. Lemurs live just off Africa's coast on the island of Madagascar. Most, but not all, species of lemur spend their lives in the trees. Not strictly vegetarian, they'll eat anything they can get their funny-looking little hands on. But then again, so will I.

The most salient feature of the lemur is its big, wide-eyed look that gives it a perpetual expression of surprise. Note the facemask, which encircles both eyes separately, repeating the shape of the muzzle. It also has quite a different nose formation from the monkey. The head is a rounded square, with small ears, and the body is compact. The lemur's tail plumps at the end. Like the ordinary monkey, the lemur hand has well-defined, individual fingers that allow it to grasp things. You can leave the fur smooth or include a few ruffles to add some character.

Nose Detail

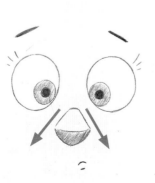

The bridge of the nose widens as it extends downward.

Semi-square face.

Surprised-looking eyes, as if lemur had facelift by Beverly Hills doctor.

Feet that grip as easily as hands do.

INITIAL SKETCH

FINAL DRAWING

GIRAFFE

We don't usually think of giraffes as cute, but the youngsters are endearingly awkward, not unlike a fawn with legs too long to manage gracefully. Space the legs apart, to show its attempt at maintaining balance, however falteringly. A bushy head of hair may not be accurate for a real giraffe, but it's more appealing than a bristle-style mane for youngsters. The head and neck make up half the height of the overall animal.

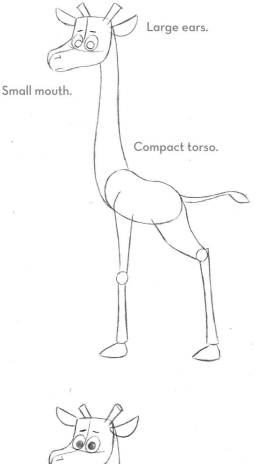

Large ears.

Small mouth.

Compact torso.

Head Details

Giraffes always have small mouths with a slight overbite. Also note the split lip. In addition, stunted horns shoot out diagonally.

Horns go out diagonally; ears sit just below them.

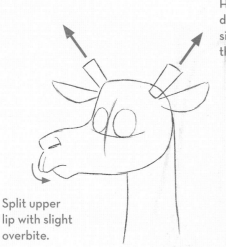

Split upper lip with slight overbite.

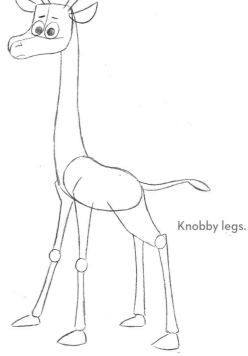

Knobby legs.

H!NT

About the markings:
Real giraffes have
some spots on their
faces, but it just clutters
up the head, visually, so
cartoonists generally
leave them off.

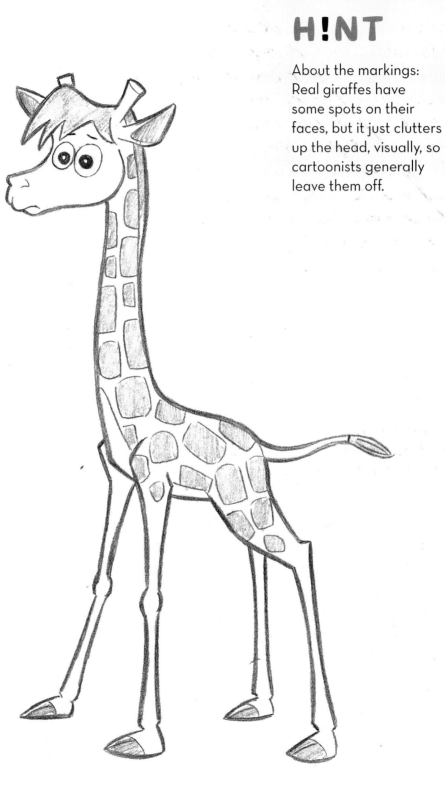

The ankle bulges just
before the foot (which
is a split-toe type).

ELEPHANT

Young elephants have a certain charm that makes them favorites among animal lovers. Real elephants have tiny eyes, but our huggable friend here has big ones with silly eyelashes fluttering off the corners. The ears are vastly oversized on both the real and cartoon versions. The huge forehead and squashed cheek area combine to give an extra-cute head shape.

The body is truncated, and there is no neck on cartoon or real elephants. And don't forget the tree-trunk-size legs. The tummy should hang low to the ground, and the feet should spread out just a bit to support the prodigious weight. Did you know that elephants spend well over half of each day eating and can consume over three hundred pounds of food per day? Did you know that after eating three hundred pounds of food, they can belch the alphabet? Just kidding.

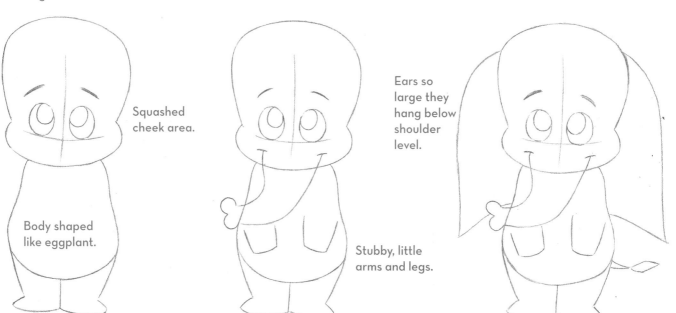

Huge forehead.

Squashed cheek area.

Body shaped like eggplant.

Ears so large they hang below shoulder level.

Stubby, little arms and legs.

INITIAL SKETCH

Even on the initial sketch, I find it helpful to shade in the interior of the ears and the eyes. This makes the character pop off the page more than if these areas are left empty, and it helps me judge whether the final drawing will work.

FINAL DRAWING

Multiple eye shines in jet-black eyes make the eyes look moist and glistening.

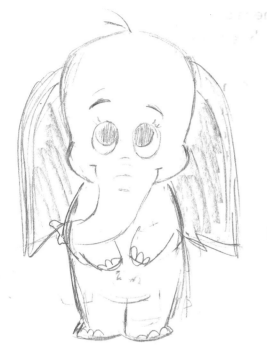

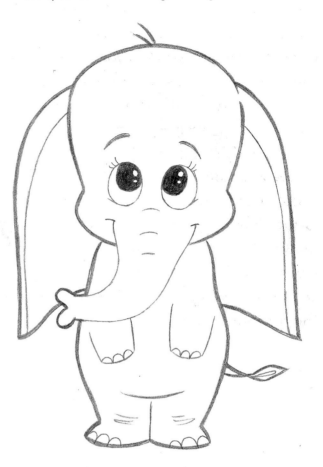

Regular Eyes vs. Cute Eyes

REGULAR EYES

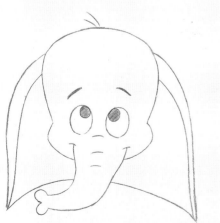

ENLARGED EYES WITH SHINES FOR MAXIMUM CUTENESS

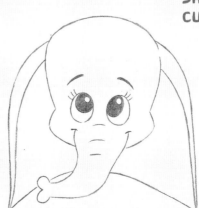

Elephant Profile

The body language here spells out the classic "concerned" look: hands under the chin and slightly pouting lips. In the side view, you can clearly see that the overall outline of the head isn't a circle but is slightly square. It's important to show the subtle indentation on the top of the head, which is an endearing feature that's unique to cartoon elephants. Another subtle thing to note: Elephants have no chins! The face stops at the lower lip.

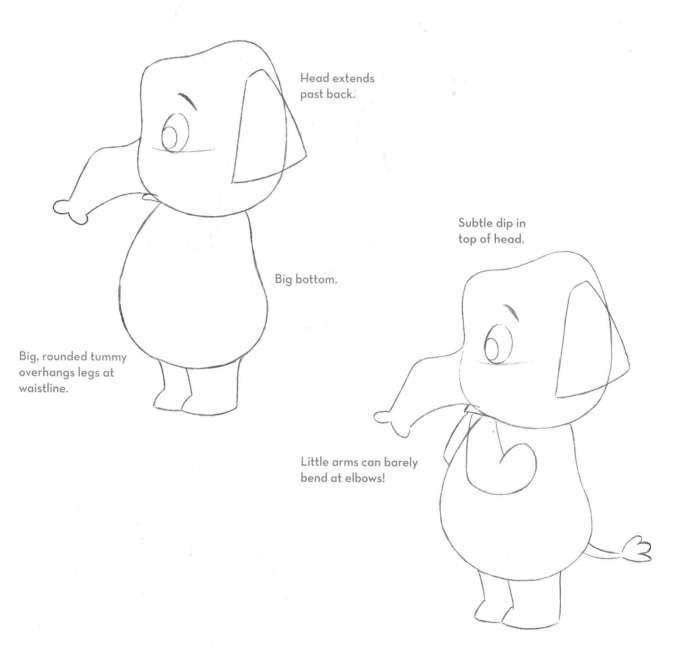

Head extends past back.

Subtle dip in top of head.

Big bottom.

Big, rounded tummy overhangs legs at waistline.

Little arms can barely bend at elbows!

Note that the eye is pushed back a few notches from the edge of the face, rather than being pressed up against the forehead.

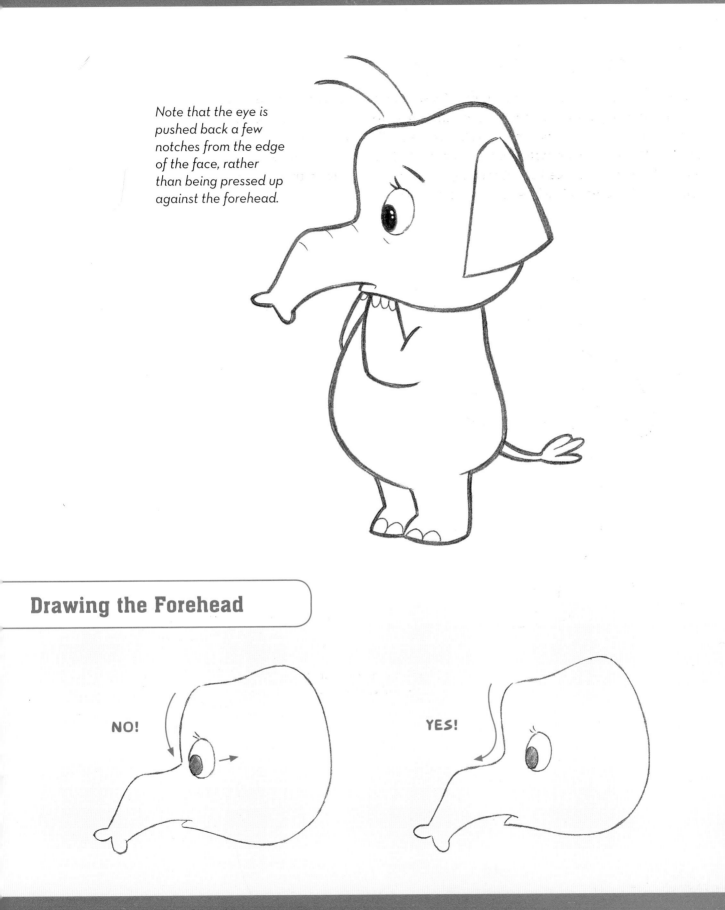

Drawing the Forehead

NO!

YES!

HIPPO

The cartoon hippo, like the cartoon elephant, is drawn standing upright, with a massive body and stubby, little limbs. Real hippos have incredibly short legs, yet they can run fast for short bursts—faster than humans! Hippos have very low foreheads—even the cute ones. Although we can increase the size of the eyes, we're limited by the low forehead that contains them. The muzzle is what really makes the hippo a hippo; it's gigantic, with huge nostrils. Another typical hippo trait is the tiny ears, which look funny on such a corpulent character. Even though hippos are, in reality, mean and scary, in cartoons they're universally portrayed as cute and fun-loving.

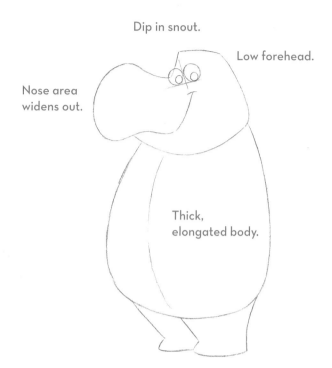

Dip in snout.

Low forehead.

Nose area widens out.

Thick, elongated body.

Hand Types

Any of these examples works well as hippo hands.

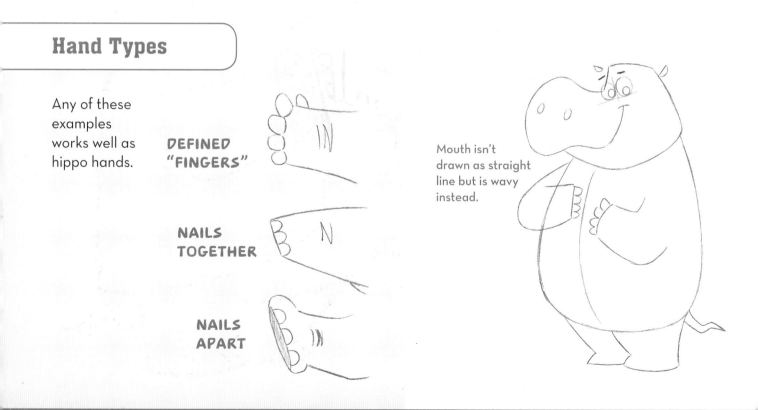

DEFINED "FINGERS"

NAILS TOGETHER

NAILS APART

Mouth isn't drawn as straight line but is wavy instead.

Small-Eyed Variation

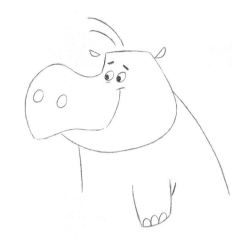

Anthropomorphic animals are humanized by their posture: They stand like people, on two legs. You can go one step farther and add "people clothes" to them, for more humor.

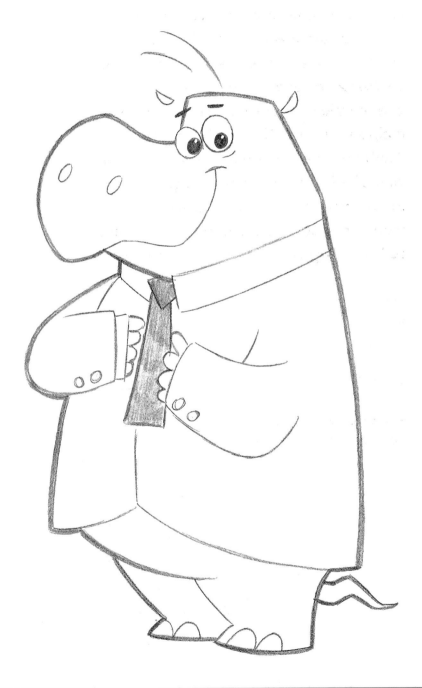

LION CUB

The lion's mane is awesome—and hard to transform into an *adorable* cartoon element. But we can omit it, because the lion's mane doesn't grow in until the male reaches adolescence. Therefore, we'll draw the lion cub instead. And that gives us an advantage, because we'll now be able to see the back of the head, which would otherwise be covered in a mane—and this gives a full sense of the dearness of the character.

A youngster's snout is short. And since the muzzle is where the teeth are, this translates into smaller teeth and less ferocity. The feet are full size, never dainty. Unlike dogs and cats, who have small tails when they're young, the cartoon lion has a long tail in proportion to its overall height, which makes it a little unwieldy and therefore humorous.

H!NT

On the final step, give your cub a slight overbite. A receding chin makes the bite look harmless.

Back sags in middle on all lions (young and old), but dip is even more pronounced on adults.

Short snout is cuter.

Large tuft of hair, thrown forward, humanizes lion.

Fat cheek area prevents lion from appearing too lean.

TIGER CUB

The cartoon tiger cub's body is drawn the same way as the lion cub, but with special markings. However, the head construction is a bit different: The chin needs to be more pronounced and the ruffles on the sides of the face emphasized.

Tigers are truly striking and my favorite animal. A word of advice: Don't overdo the stripes. A few stripes, repeated judiciously, will make a much better impression than a multitude of crisscrossing bars all over the animal's head, body, and tail. For example, only a few short stripes are needed on the face. And keep in mind the important fact that tigers have extra-wide cheeks that ruffle at the edges.

Ears are not round but come to a point.

Extra-wide cheeks are important to support fur ruffles.

Short cheek area on tigers.

Big paws.

Ruffle fur here.

Jutting chin.

Shadow line shows original head size.

INITIAL SKETCH

You can see by the shadow line that I was trying different head sizes before settling on the final one.

FINAL DRAWING

CHEETAH

Cheetahs cannot be drawn pudgy. By definition, they are lithe, lean, and super-quick animals. You can't "pudge them up" to make them look cuter or they won't look like cheetahs. They're very chesty animals, with narrow waistlines and tapered limbs, which makes for an extremely athletic-looking character. The legs are long and thin—built for speed. But if they're not roly-poly cute, neither do they have to be ferocious looking in cartoons. You can make them highly appealing by working the expression, giving them big eyes and an affable smile or an innocent look. No teeth showing and big, open eyes translate into a friendly character. Markings are made up of uneven spots.

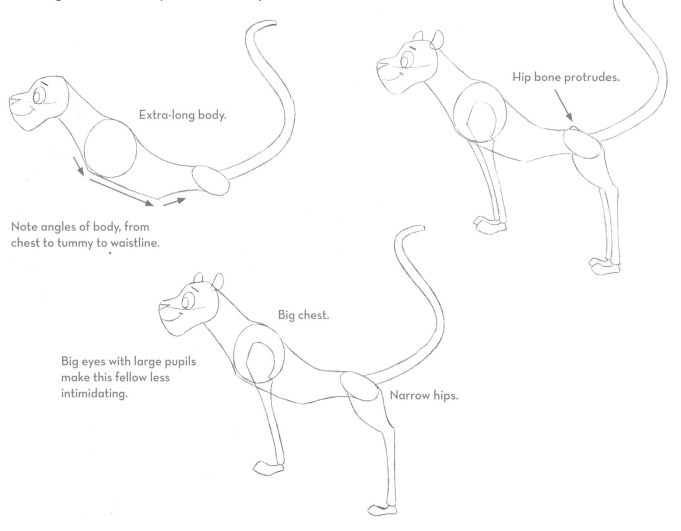

Extra-long body.

Note angles of body, from chest to tummy to waistline.

Hip bone protrudes.

Big eyes with large pupils make this fellow less intimidating.

Big chest.

Narrow hips.

X-Ray Vision: Cheetah Joint Configuration

This is a simplified yet accurate diagram of the joint configuration of the large cat. On the cheetah, note that the bones and limbs are thin and light—built for speed.

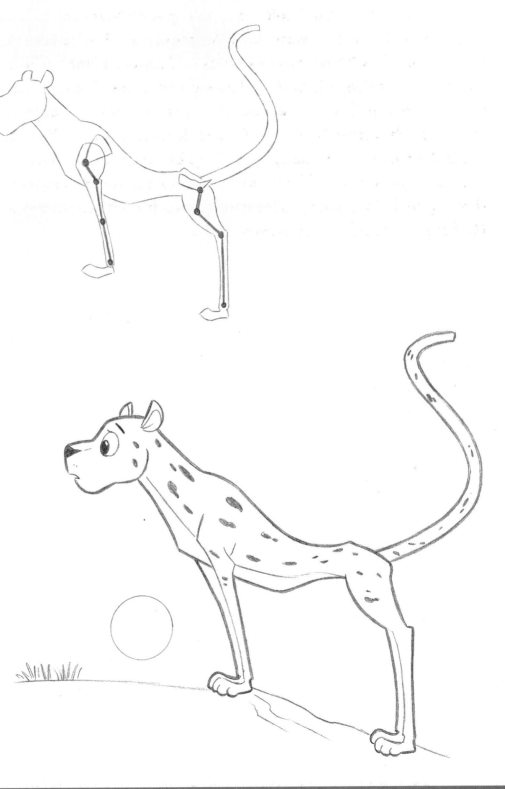

H!NT

Cheetahs have relatively small heads compared to their overall body length.

HORSE

People often have trouble drawing horse faces, and it's generally for one of two reasons: They draw the muzzle too small, or they don't draw a massive enough jaw area. Appealing cartoon horses have a long, gently sloping line that runs from the top of the head down the bridge of the nose. The younger the horse, the more the forehead slopes.

Always draw the mane after the underlying structure is set in place. The mane should add some height to the top of the head, and even to the neck, in cartoons.

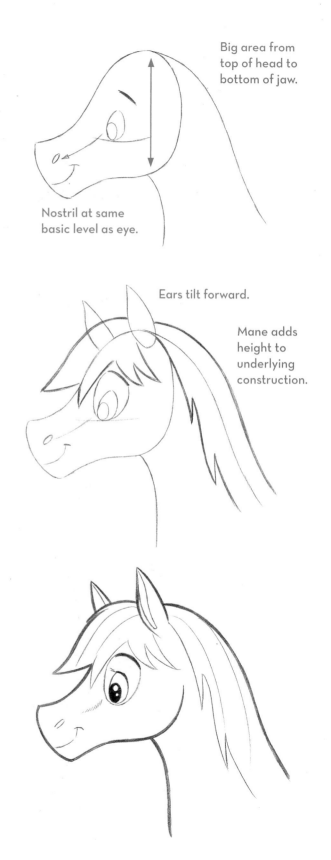

Big area from top of head to bottom of jaw.

Nostril at same basic level as eye.

Ears tilt forward.

Mane adds height to underlying construction.

"Cheating" Profile

Showing one eye in the profile view is cute, but having two eyes on the same side of the head is a funnier look.

TRUE PROFILE

"CHEATING" PROFILE

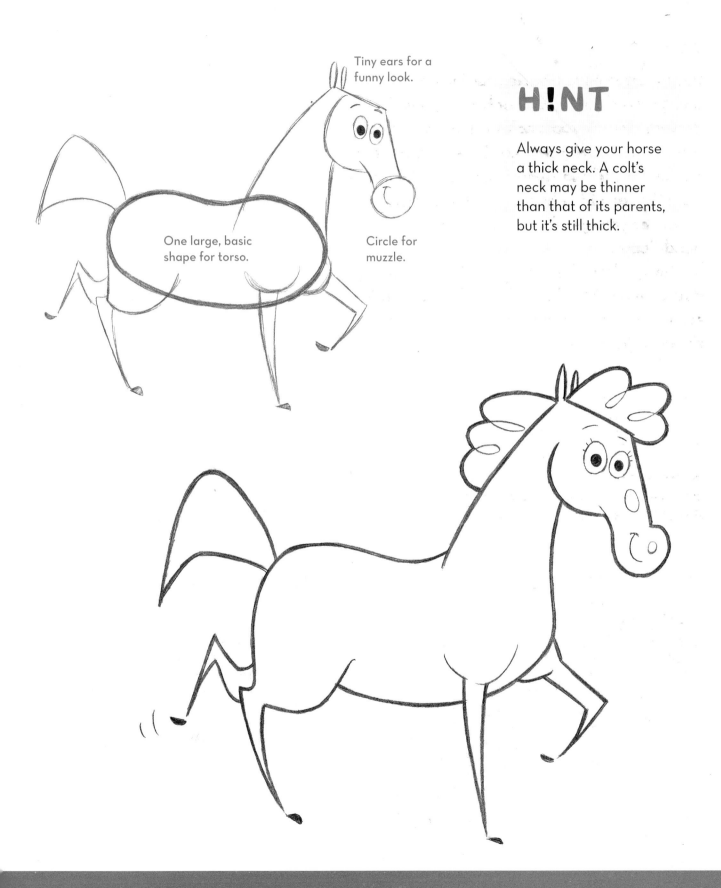

Tiny ears for a funny look.

One large, basic shape for torso.

Circle for muzzle.

H!NT

Always give your horse a thick neck. A colt's neck may be thinner than that of its parents, but it's still thick.

ZEBRA

Zebras aren't simply horses with stripes. In addition to being smaller than horses, real zebras have squatter bodies and bigger rumps, which gives them a humorous appearance in cartoons, as well. Their legs are stockier looking and not as bony as those of horses. And their mane is very bristly, sticking straight up instead of lying flat. They may be less elegant than horses, but that only serves to make them better material for cartooning. But by the way, they're just as fast as horses!

Alternate Character Design: Wacky Zebra

Here, the original anatomy of the zebra is replaced with a sort of weird, pot-bellied human body, but with a horse's long neck. And improbable as it may seem, it works! There are a lot of extreme cartoons today that incorporate just this type of technique when coming up with new character designs. Wacky animal cartoons are very trendy. But they can be plenty cute and appealing, too! Note the silly flat-footed, human posture.

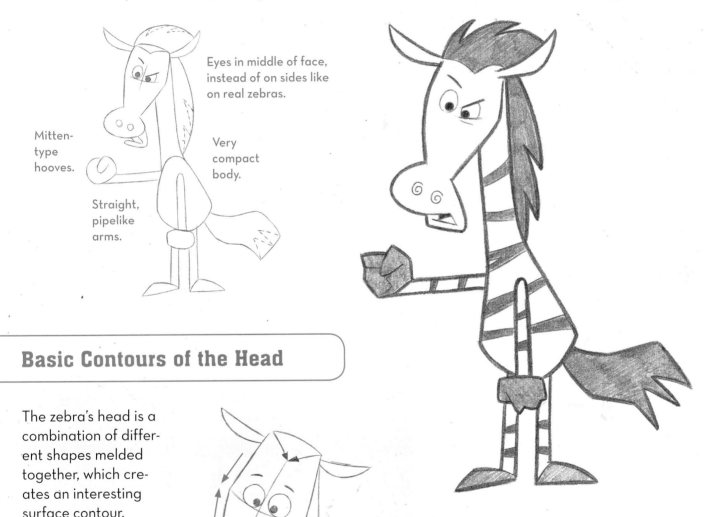

Eyes in middle of face, instead of on sides like on real zebras.

Mitten-type hooves.

Very compact body.

Straight, pipelike arms.

Basic Contours of the Head

The zebra's head is a combination of different shapes melded together, which creates an interesting surface contour.

KANGAROO

Kangaroos are often portrayed as fun-loving, carefree cartoon animals. As such, these guys, especially the little ones, should pack some major "boing" in their jump. The body is a teardrop shape, with a thick tail that trails behind. They have big ears and feet. Their arms are small and little used. The knee goes way up into the chest area when preparing to jump or recoiling from a jump. The thighs bulge when the knees are bent.

The Kangaroo Leg

When the leg is fully bent, it bunches up and looks fatter, and you can see this in the progression here as the leg lands and then jumps up off the ground.

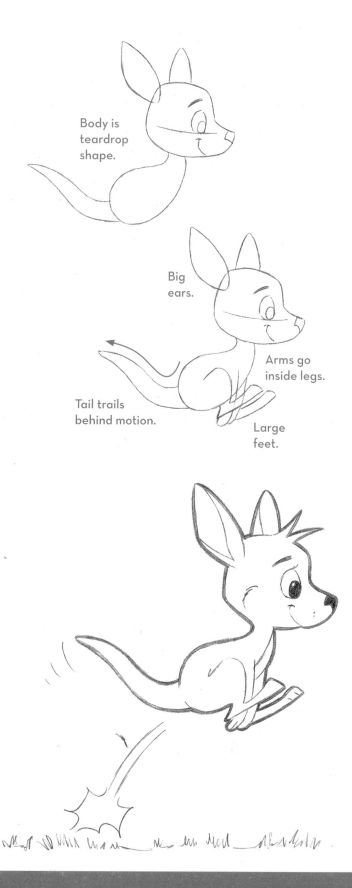

Body is teardrop shape.

Big ears.

Tail trails behind motion.

Arms go inside legs.

Large feet.

MEERKAT

These creatures are small and approximately a foot tall, give or take. They're fuzzy, energetic, and ever vigilant. Meerkats may be small, but they have outsized personalities. They're sociable and gregarious. The face is raccoonlike but not as wide. The meerkat has a few stripes down the middle of its back but not the hallmark striped tail of the raccoon. The tail of the meerkat is, in reality, long and thin, so we fluff it up a bit to make it more attractive.

Meerkats are always drawn standing on two legs, like little people, and in reality, the meerkat is one of the few mammals that really does spend a lot of time standing upright, on the lookout for danger.

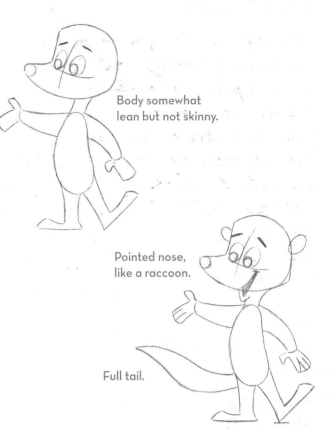

Body somewhat lean but not skinny.

Pointed nose, like a raccoon.

Full tail.

Eye Placement

In cartoons, we can sometimes break with logic to make a stylistic choice. For example, it's sometimes funnier to draw both eyes on the same side of the face instead of on either side of the bridge of the nose, which makes more sense anatomically. So here the eyes appear on either side of the bridge of he nose. But in the drawing to the far right, both eyes are on the same side of the nose.

Bridge of nose.

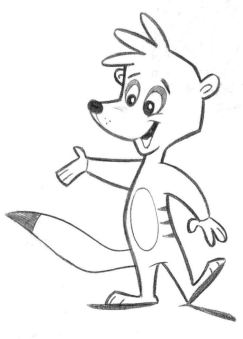

For the Birds!

Birds are versatile and adaptable creatures, which makes them perfect subjects for cartoon characters. Some fly, others can't but do run on land, while still others mainly swim. They range from super-tiny (hummingbirds) to extravagantly large (ostriches). The beak replaces the snout and muzzle of mammals but serves the same purpose: It provides a protrusion for the face. Each beak is unique; the shape and size identify the particular species of bird in the same way that a type of ear might identify a particular breed of dog. As to the feathers, we simplify them, focusing on the overall shape of the wings and tail.

THE SUPER-POPULAR PENGUIN

Penguins are in a league of their own. They have waddled their way into award-winning comic strips and even starred in their own animated movies. And yet, despite all this popularity, the features of a penguin remain a little mysterious. Everyone knows what a parrot's beak looks like. But can you recall what a penguin's looks like? What about the true shape of its head? Don't worry. I've got you covered.

While still an exaggeration, this penguin is nonetheless a fairly good reflection of real penguin structure. Penguins actually have very small heads with short, sharp beaks. They're bottom heavy with ultra-short legs. What they don't have are a duck's webbed feet—but they're often portrayed that way in cartoons because it looks funny. And funny is good!

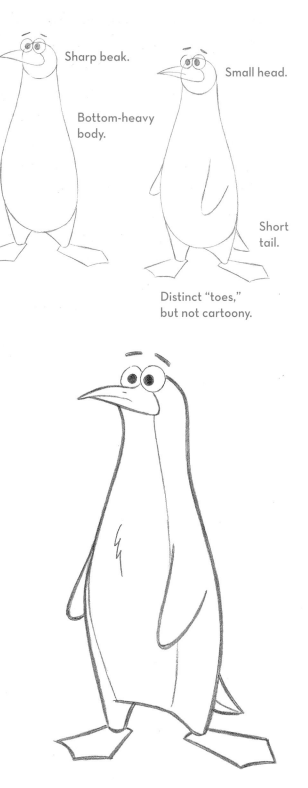

Sharp beak.

Bottom-heavy body.

Small head.

Short tail.

Distinct "toes," but not cartoony.

Penguin Feet

STRAIGHT-ON

3/4 VIEW

SIDEWAYS

OSTRICH

Ostriches are always a bit on the goofy side. And because of the way they're built, that's the only way to go. That tall neck rises up into a receding chin, producing a silly expression. The real ostrich actually has a very large body (torso). But we trim it down a bit, so it looks more compact and, therefore, cuter and funnier. The wings can remain huge and can double as hands. The head is always small—you can't change that without losing the essence of the bird. But you can increase the size of the eyes, which are tiny on the real bird.

No chin.

Truncated egg shape for body.

Thighs are thicker than lower legs.

Squiggly feathers are funny.

Fat toes!

H!NT The weak chin makes the ostrich appear friendly.

PELICAN

The distinctive pouch on the pelican's beak is, of course, essential to the bird's character design. However, just as important is the fact that the upper bill is long and thin but fattens a bit at the end. The neck doubles back on a real penguin. But this makes it less appealing as a cartoon character, so you can straighten it out if you wish. The true pelican's pouch is small when not in use, but that prevents us from showing, to full extent, the most salient feature of the bird. For cartoons, keep the pouch bucket-shaped at all times. Including its beak, the head is somewhat oversized compared to the body.

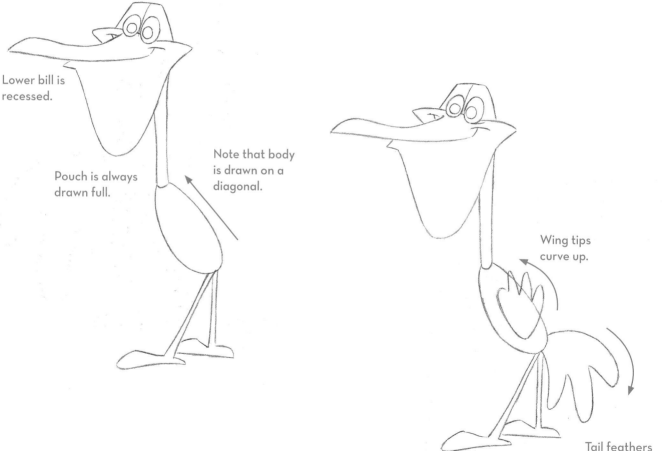

Lower bill is recessed.

Pouch is always drawn full.

Note that body is drawn on a diagonal.

Wing tips curve up.

Tail feathers turn down.

Many artists draw the pelican's neck curving upward to the head. I like to draw it straight. That gives the character a bright-eyed, alert look.

Bird Mouths

When a bird opens its beak, it shows no teeth but instead a floating tongue in the middle of the mouth.

HUMMINGBIRD

The hummingbird may be the smallest bird on the planet, but the head is oversized compared to its teeny body—at least on cartoons it is. In fact, the cartoon hummingbird's head is much larger than its entire body! Hummingbirds are best depicted hovering in flight, a hallmark ability of this particular bird. By drawing them getting nectar from a flower, you get the added benefit of scale: Juxtaposing them next to the flower shows just how small the hummingbird really is. Spread the wings as wide as possible to make it look like the wings are flapping. Real hummingbirds flap their wings so fast that they appear as a blur. Some cartoonists prefer to draw the wings as a blur rather than as the solid wings you see here.

Cheek gets big "bump-out."

Legs stay skinny and, therefore, look almost weightless.

Super-long, skinny beak.

Eyes spaced evenly apart on either side of center line.

Short wings keep body looking small.

Line of smile runs entire length of beak.

Hummingbird Proportions

The hummingbird head is significantly larger than the entire body, including the tail!

RETRO BIRDS

These zany little birds roam parks looking for bread crumbs and anything else they can pilfer. They have very sharp designs, with oversized eyes, miniaturized bodies, and super-thick outlines. Often, they're a comedy team: one angry, the other dumb. They work off each other, with the angry one constantly getting burned up at the stupid suggestions of his dim-witted buddy. A classic comedy duo.

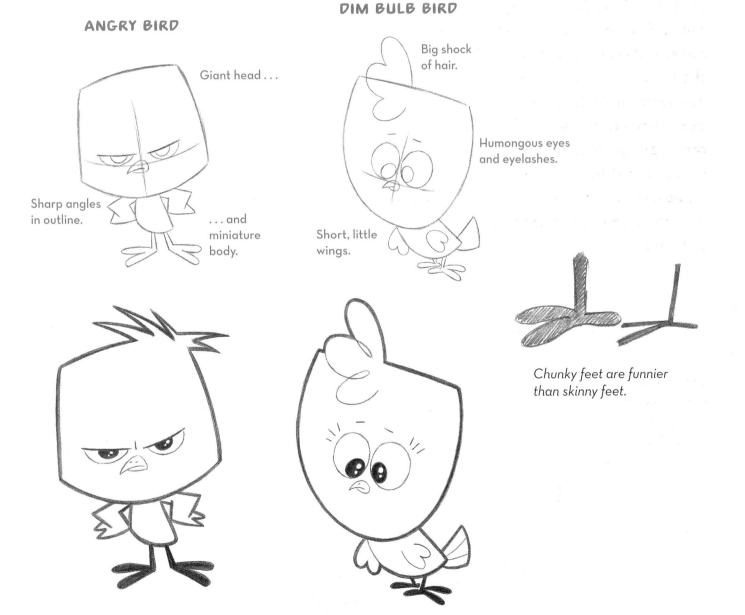

DIM BULB BIRD

ANGRY BIRD

Giant head . . .

Big shock of hair.

Humongous eyes and eyelashes.

Sharp angles in outline.

. . . and miniature body.

Short, little wings.

Chunky feet are funnier than skinny feet.

DUCK

Ducks are the most popular cartoon bird, second only to penguins. Since the early days of animation, there have probably been more cartoons featuring ducks than any other bird. They are famous for their harmless-looking, upturned bills (by contrast, predatory birds have pointed beaks). Ducks waddle humorously on land instead of hopping from spot to spot the way other birds do. This is due to their short legs and big, cumbersome feet, which are excellent for swimming only. On land, there's no such thing as a fast-moving duck.

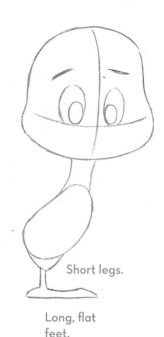

Short legs.

Long, flat feet.

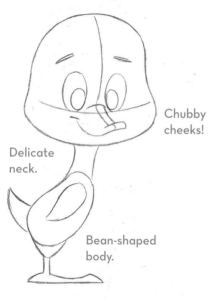

Delicate neck.

Chubby cheeks!

Bean-shaped body.

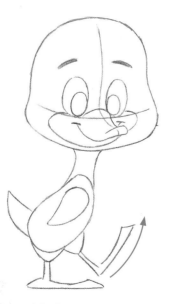

Paddle foot bends backward when duck walks forward.

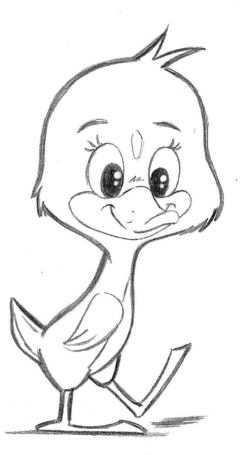

Alternate Character Design: Retro Duck

Here's a different style of cartoon duck, a little more retro looking. The head is squarer, the body is tiny, but the neck is long. Notice that the beak is drawn off to one side even though the duck is facing straight forward. This is a "cheat," but it makes the beak read more clearly than if it were flattened out due to foreshortening. Retro characters are often noted for cheating on the nose (or beak) as well as the eyes. The feet are drawn at a diagonal, instead of pointed sideways, so that we can see the webbed tips of the toes.

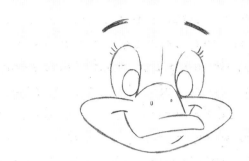

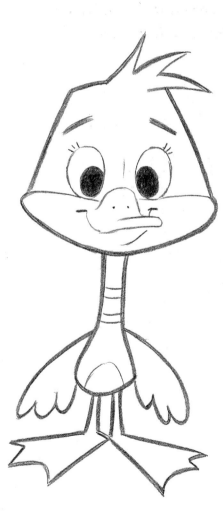

Super-stylized body.

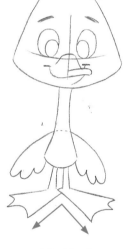

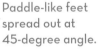

Paddle-like feet spread out at 45-degree angle.

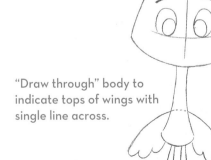

"Draw through" body to indicate tops of wings with single line across.

Sea Life &
Reptiles

Anyone who has watched TV knows how popular animated shows like *SpongeBob SquarePants* are. Films like *Finding Nemo*, *Shark Tale*, and *The Little Mermaid* proved the popularity of undersea cartoon characters in animated movies. But few cartooning books have anything to offer in this area, which is why it's important to include a chapter for drawing appealing sea life. Fish look very different from mammals, but many of the same character design principles still apply, albeit tweaked a little. Therefore, you'll catch on quickly as we make our way though the enchanted ocean. Fish and reptiles make colorful, expressive cartoon characters. They're especially adaptable to exaggeration in character design, because of their rounded and odd shapes.

CLASSIC FRIENDLY CARTOON FISH

This isn't a specific species but an amalgamation of various small fish all rolled up into one. It could easily be an aquarium inhabitant or a small member of a school of ocean-going fish. Either way, it has the standard look for a friendly type of underwater pal. Unlike mammals, the small fish has no snout or muzzle whatsoever! But it's got big eyes and thick lips. A dorsal fin decorates the top, and side fins can be drawn to any length. This one has long side fins to give it a standout quality.

H!NT Tiny tail fins add humorous contrast to a fat body.

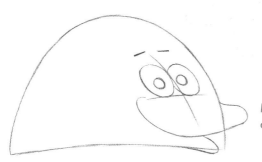

Major overbite and thick lips.

Instead of giving a fish a muzzle, try giving it thick lips. You need to do that to increase its mouth area, since it's missing a nose.

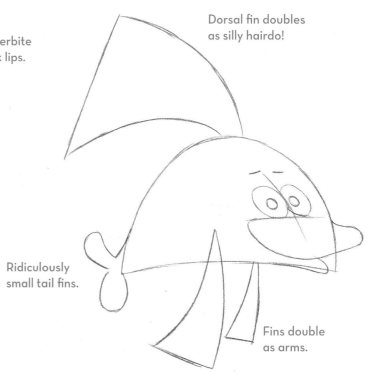

Dorsal fin doubles as silly hairdo!

Ridiculously small tail fins.

Fins double as arms.

Note that the back of the fish is a long, arching curve, but the tummy is a flat line. Juxtaposing curves and straight lines against one another helps to create dynamic character designs.

Generic Fish Body Types

ELLIPSE

CRESCENT

CHUBBY
ELLIPSE

INVERTED
CRESCENT

SWORDFISH

While the swordfish does have a "sword" on its nose, it doesn't have to look intimidating if the expression is friendly and the pupils of the eyes are oversized. The side fins of the swordfish are attached close to the head—not midway back on the body, as they are on many other fish. The dorsal fin on the back is showy but thinner than that of a shark. Real swordfish also have a bottom fin on the tummy, but that's generally a superfluous detail that's eliminated on cartoons. I like to draw both eyes on the same side of the sword, as I believe it gives the character a sillier charm—and a retro, rather than aggressive, feel.

Back curves up. (Compare to dolphin's back, which curves down.)

Fin is placed right next to head.

Sword becomes line of mouth.

SEA HORSE

A big head on a curlicue body is a funny look. I don't articulate the actual bony protuberances as they appear on real sea horses—except for the back plates. Bony skin texture robs the character of its charming look. Keep it smooth. And keep the fins really tiny. This is a delicate little fella with a nervous disposition, always on the lookout for trouble!

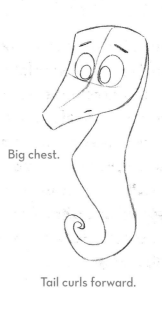

Big chest.

Tail curls forward.

Guideline will be removed in final step.

Sea Horse Tip

Use an initial guideline to keep the tips of the back plates aligned.

SEAL

There are many types of seals: the fur seal, the leopard seal, and the harp seal, to name a few. This cartoon seal is a classic combination of them all. Seals are the dogs of the sea: happy, peppy, eager, and fun-loving. They have huge, glistening eyes that make them irresistible and little ears on the sides of their head, which are generally eliminated in cartoons and are difficult to see even on real seals. Their simple design is part of their appeal.

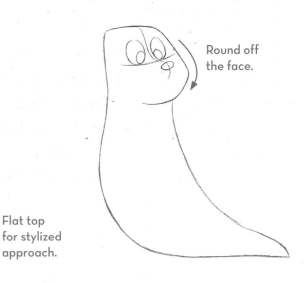

Round off the face.

Flat top for stylized approach.

Feet, not tail fins.

H!NT

Those are feet at the end of the seal body, not tail fins. Because of that, they're floppier than fins.

DOLPHIN

Dolphins are favorites of cartoon-animal lovers. Keep the teeth small so that they don't look menacing. The snout is pronounced and sometimes referred to as a beak. The forehead is bulbous, giving the character a baby-headed look. Dolphins are sleek but never skinny. They have a famously convex curve to the back. They should always look round and well fed.

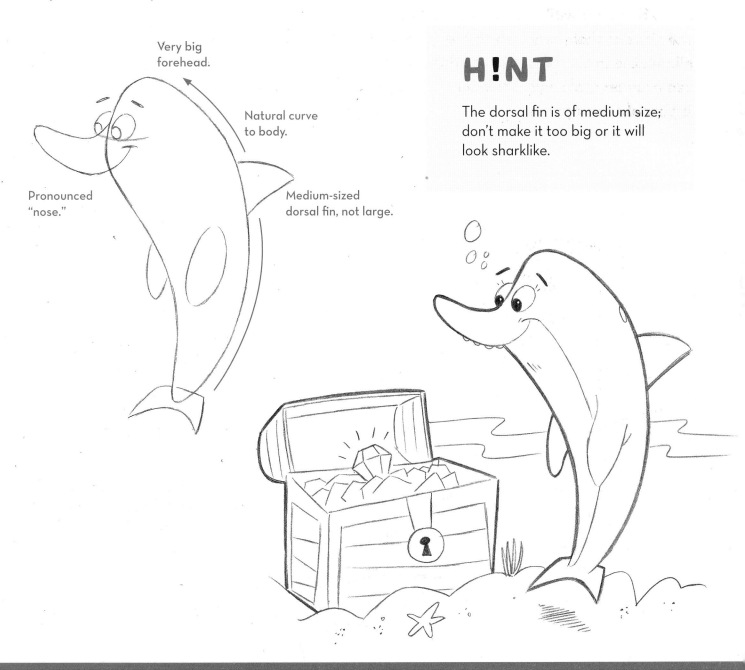

Very big forehead.

Natural curve to body.

Pronounced "nose."

Medium-sized dorsal fin, not large.

H!NT

The dorsal fin is of medium size; don't make it too big or it will look sharklike.

WALRUS

The walrus is the funny old man of the sea. With his copious whiskers and big maw, he always looks jolly. The top of the head should be round, like a bald man's head. The feet are in the shape of two flippers, certainly nothing the walrus can use to walk upright—unless you really want to go extreme. Small arms are funny on a character as large as this guy.

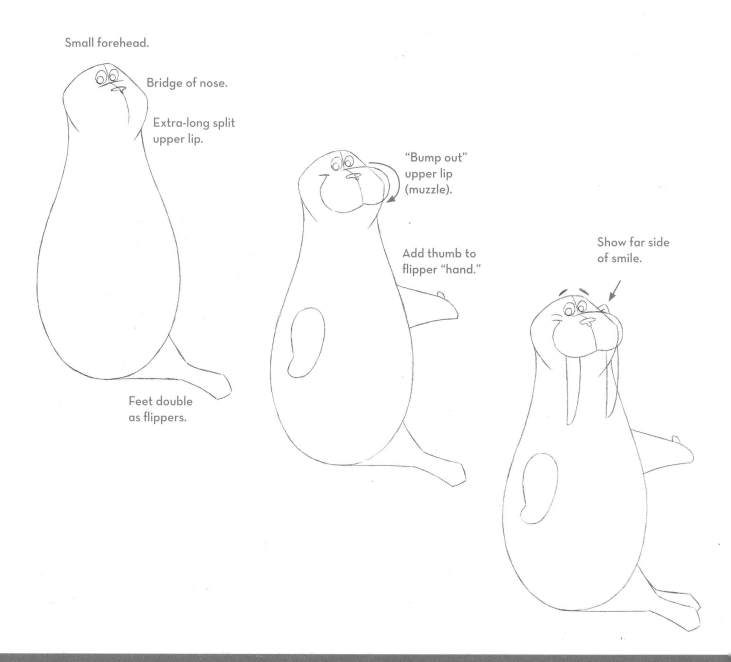

Small forehead.

Bridge of nose.

Extra-long split upper lip.

Feet double as flippers.

"Bump out" upper lip (muzzle).

Add thumb to flipper "hand."

Show far side of smile.

Walrus Details

The walrus's low forehead leaves no room for eyebrows inside of the face. Because of this, I like to place the eyebrows outside the outline of the face. It's humorous to have floating eyebrows; plus, it frees them from any spatial limitations.

The mouth and split lip together form an upside-down Y shape. The tusks should be very long. Since they angle down, and not inward, they don't appear aggressive. Long whiskers are always a good touch, as well as a few dots ("whisker marks") on the upper lip.

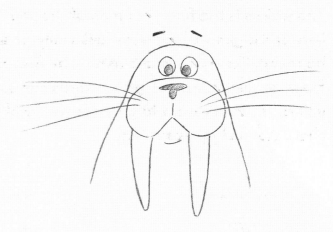

INITIAL SKETCH

Usually I use a thin line for the sketch, but on this guy, I decided to thicken even the first rough draft, because the outline of his body is so big that a thin line seemed too delicate.

FINAL DRAWING

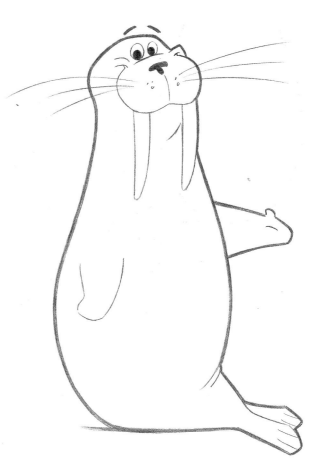

PLATYPUS

The Australian platypus is certainly an odd-looking creature, but a cute one nonetheless. It has webbed feet attached to little arms. It's always pudgy looking and well fed. Cartoonists like to greatly exaggerate the head size of most animal characters to make them more endearing; however, the platypus is such a strange-looking creature as it is that any gross exaggeration of its head size will make it unrecognizable. And since it's a rather obscure animal anyway, it's best to leave the head in relatively realistic proportion to the body.

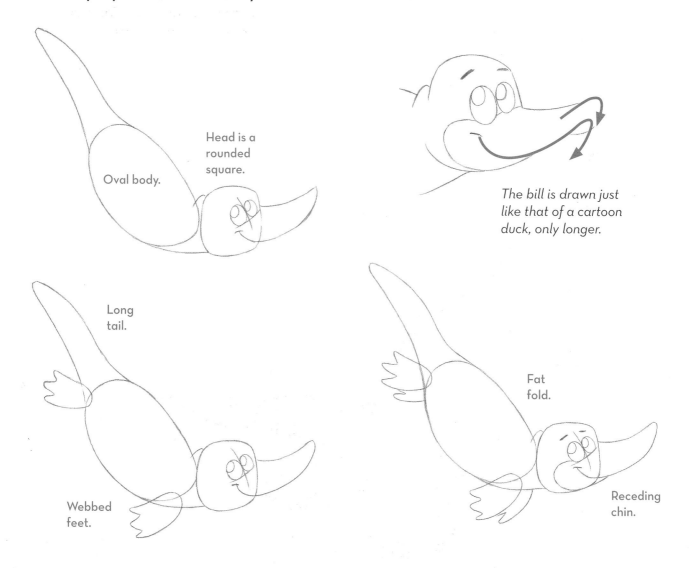

Oval body.

Head is a rounded square.

The bill is drawn just like that of a cartoon duck, only longer.

Long tail.

Webbed feet.

Fat fold.

Receding chin.

INITIAL SKETCH

The original pencil sketch shows that I, too, initially sketch the head as a distinct shape, just as I suggest you do!

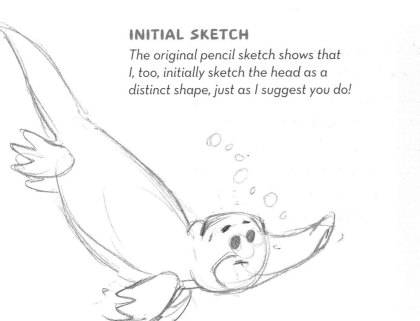

H!NT

Platypuses like to dive. When drawing an animal diving in the water, it works best to draw it on a diagonal. If you draw it going straight down, vertically, it's hard to read the image. I like to have some air bubbles trailing the critter. This makes it clear that we're in an underwater environment.

FINISHED DRAWING

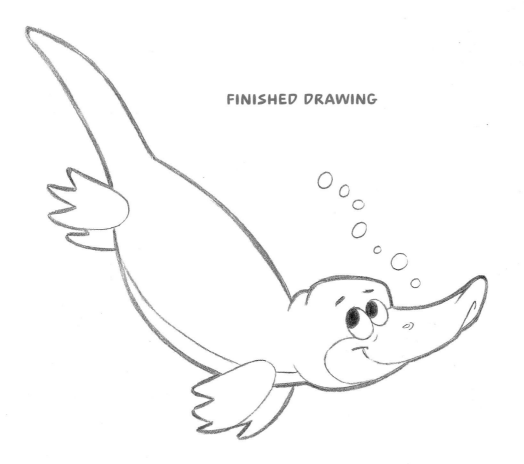

OTTER

Otters have a real zest for life and a love for play, which should show in their expression and body language. Otters are excellent swimmers. They have the cute head of a woodland creature but with a sleek body suited for cutting through the water. Although they have enough padding to insulate them from the cold waters, they are never fat. Note the long legs and long tail.

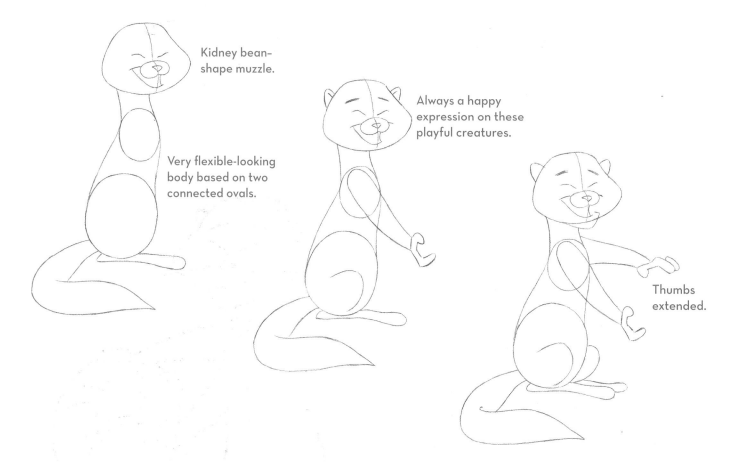

Kidney bean–shape muzzle.

Very flexible-looking body based on two connected ovals.

Always a happy expression on these playful creatures.

Thumbs extended.

H!NT Shellfish is a staple of the otter. For a funny look, draw the abalone, or giant clam, with an opening like a sort of squiggly mouth running across the shell.

Foot Tip

NO!
This foot has too much mass at the toes.

YES!
This foot remains thin and flat.

Hand in front of clam.

Hand underneath clam.

TURTLE OR TORTOISE

In cartoons, reptiles don't seem cold-blooded at all. They're just as irresistible as any other appealing animal. But to create them that way, we must enlarge the eyes and make them rounder. Also, we give them fat cheeks, which all real reptiles lack. None of this is difficult to do. It's all a matter of making little adjustments to the head.

Cartoon turtles are generally drawn as tortoises rather than as deep-sea turtles. The thin arms and legs of the sea turtle are less appealing than those of its land counterpart, the tortoise. The tortoise's hands and feet look similar to those of a cartoon elephant. The back of the shell on the tortoise is quite high, whereas it is much flatter on a sea turtle. And the face of a tortoise is more square and pleasing than that of a sea turtle, whose face is narrower and shaped to better slice through the water.

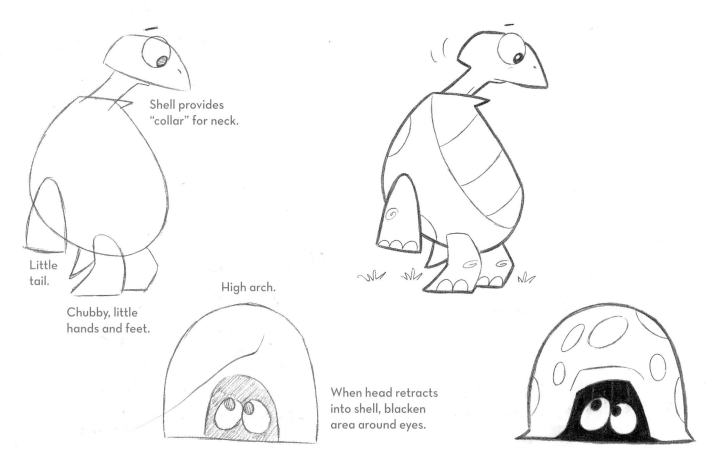

Shell provides "collar" for neck.

Little tail.

Chubby, little hands and feet.

High arch.

When head retracts into shell, blacken area around eyes.

FROG

The frog is a simple animal to draw. But because it's so simple, you've only got a few features to work with, and therein lies the challenge: making it look like something without a lot of detail. The keys are the bumpy ridges that frame the huge eyeballs (which are often depicted with tiny pupils) and the protruding upper lip area (which almost looks like a shortened duck's bill). Although frogs have long legs, you can only see that when the legs are extended. And that rarely happens because it occurs so quickly—only when they hop. Instead, the legs are almost always seen curled underneath the body and bunched up.

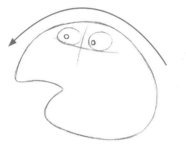

Huge, arching line from back to tip of nose.

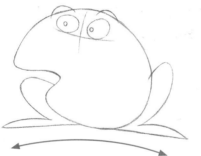

Legs and tummy drawn along same line.

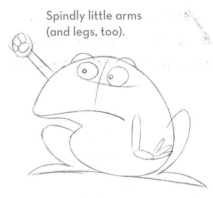

Spindly little arms (and legs, too).

"Hand" Variations

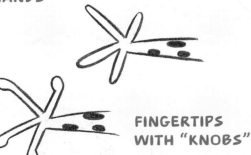

REGULAR FROG "HANDS"

FINGERTIPS WITH "KNOBS"

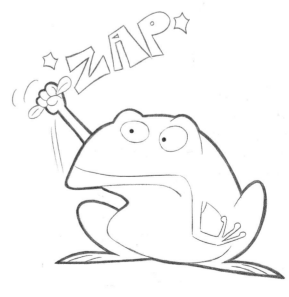

ZAP

ALLIGATOR

An alligator snout is wider than the narrow, pointy nose of the villainous crocodile. As such, the alligator looks friendlier and makes a cuter cartoon character. To make the alligator appealing, I've designed him to be quite young and small—sort of the opposite of what you think of when you think of alligators. Here, he's a helpless little guy. It's appealing when you give predatory animals harmless characteristics and expressions. It's a good approach, because it provides a twist on the conventional thinking about character types.

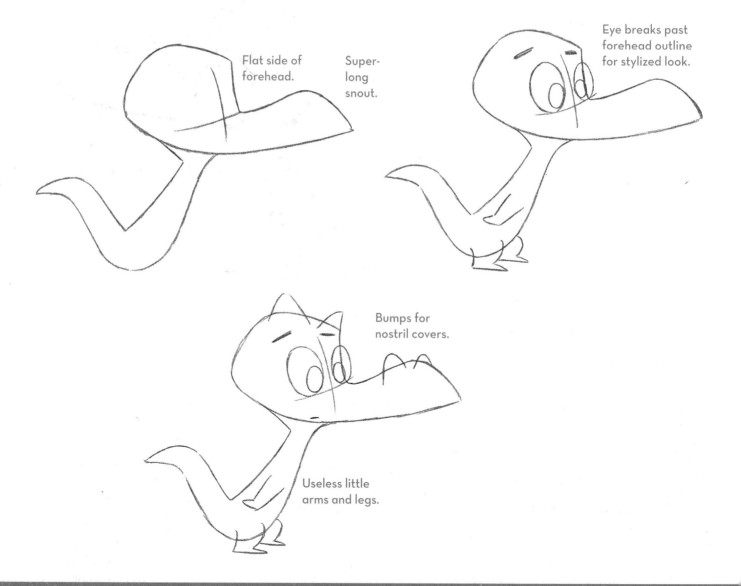

Flat side of forehead.

Super-long snout.

Eye breaks past forehead outline for stylized look.

Bumps for nostril covers.

Useless little arms and legs.

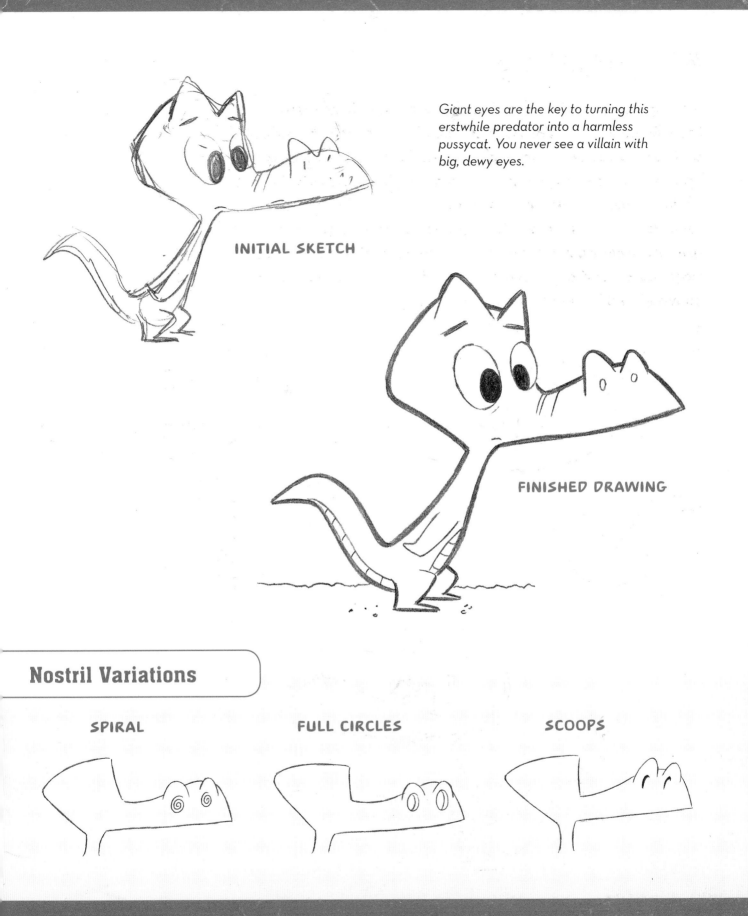

INITIAL SKETCH

Giant eyes are the key to turning this erstwhile predator into a harmless pussycat. You never see a villain with big, dewy eyes.

FINISHED DRAWING

Nostril Variations

SPIRAL

FULL CIRCLES

SCOOPS

Index